CW00504570

BURMA RAILWAY ARTIST
The War Drawings of Jack Chalker

To 'Weary', one of the few truly great men
of our time, a dear friend and mentor, to whom so
many of us owe so much.

BURMA RAILWAY ARTIST

The War Drawings of Jack Chalker

JACK BRIDGER CHALKER

FOREWORD BY SIR EDWARD ('WEARY') DUNLOP

LEO COOPER
LONDON

First published in Great Britain in 1994 by
LEO COOPER
190 Shaftesbury Avenue, London, WC2H 8JL
an imprint of
Pen & Sword Books Ltd,
47 Church Street, Barnsley, South Yorkshire S70 2AS

Copyright © Jack Bridger Chalker, 1994

A CIP catalogue record for this book is available from the British Library.

ISBN 085052–337–0

Typeset in Bembo 12/15 point by Bookset
Design by Guy Mirabella

Typeset in Bembo 12/15pt by Bookset
Printed and bound by Redwood Books
Trowbridge, Wiltshire, England

CONTENTS

ACKNOWLEDGEMENTS

MY COLLECTION of about 150 small war drawings and paintings have remained packed away in the studio for nearly half a century and, apart from copies made in Bangkok being used about the world in various publications without my previous knowledge or permission, they had been almost forgotten.

Six years ago, much to my delight, Sir Edward 'Weary' Dunlop asked to include some of them in his book, *The War Diaries of Weary Dunlop* (1986) and this triggered a revival of interest in the collection as a whole. As a result I am deeply indebted to him and to many Australian POWs, friends and others beyond those times who have encouraged me in an attempt to produce the drawings in a book.

In particular, I owe so much to Patsy Adam-Smith OBE, Susan Haynes, John Clarke and Martin Flanagan, whose great kindness, interest and expertize have made this book a reality. Its origin lies in the Thai jungle prison camps where I had the great privilege to meet and to work with Sir Edward (then Colonel Weary) Dunlop of the Australian Army Medical Corps, to whom so many of us owe our lives and whose interest and support for the maintenance of those records during our captivity played a crucial part in their survival.

I am grateful also to staff at the Imperial War Museum, London, for their assistance, and to David Bergamini, whose book *Japan's Imperial Conspiracy* (1971) helped me considerably, as did Weary Dunlop's article 'Medical Experiences in Japanese Captivity' published in the *British Medical Journal* of October 1946.

I am also indebted to my wife Hélène for her patience and support during my months of isolation in the studio whilst struggling to produce a manuscript.

FOREWORD

THE MANY FRIENDS and admirers of the distinguished British artist whom we know as Jack Chalker will be delighted to find that he is at last publishing a book devoted to his very varied experiences in the Second World War. He brings to the task the discerning eye of the artist and illustrator trained to observe and record, thus providing access to a gallery of visual images which are further illuminated by the sensitive articulate expression that he brings to writing.

His extreme generosity rendered available to several nations the drawings and paintings resulting from his enterprise during Japanese captivity. These have enlivened the books and medical publications of others, including my own.

I first encountered Gunner Chalker in a large, primitive prison-camp hospital in Thailand, as a stripling Michelangelo whose nose, due to onslaught by a Japanese guard, had a similar malalignment to that of the Master. With the almost complete absence of prisoners' photographic records, I realized the immense historical value represented by his ability to record accurately not only the misery, squalor, savagery, heroism and fortitude of prison camps, but also the horrendous detail of diseases, wounds, and the ravages of starvation suffered by those in jungle hospitals. Thereafter I did my best to ensure that, under cover of nursing and physiotherapy appointments, he was given some measure of protection to carry out this risky but vital activity. His gentle compassion, keen intelligence and sensitive hands made him a marked asset in either capacity.

It is a fascinating story in itself, just how much ingenuity and improvisation was required to produce drawing and painting materials, with scraps of paper and cloth as his canvas, let alone the furtive secrecy required to carry out the work, mainly on his bamboo bed space. The preservation of these records was something of a nightmare task due to frequent searches by guards of hutments and personal gear. Their very nature rendered their possession hazardous. The

harsh conditions of Japanese prison camps and hospitals verified the truth of Shakespeare's 'Sweet are the uses of adversity'. Whilst it was of supreme importance to maintain the chain of rank, order and discipline, despite the humiliations meted out to officers and NCO prisoners, there emerged a new dimension of human stature measured by personality and ability to make a contribution to corporate sanity and survival.

I recall that in a large prison camp I commanded in Bandung, Java, which was occupied by British and Commonwealth naval, army and airforce servicemen, personalities who captured the imagination included those from the lowest rank in each service as exemplified by LAC Don Gregory, a classics don from Cambridge who enthralled with his talks on Graeco-Roman history. There emerged a public esteem not only for those who contributed ingeniously to practical measures of survival, but also for those whose physical, social, intellectual or spiritual qualities were uplifting.

Jack Chalker was one of those I judged 'a man in a thousand'. The stripling youth in appearance displayed both physical and mental toughness, and his artistic sensitivity was tempered by humour, irony and considerable maturity in his reaction to adversity. It is little wonder that his account of early service in the British Isles during the 'phoney war', the circuitous sea voyages to America, South Africa, India, and the final débâcle when his division was sacrificed to the practically hopeless defence of Singapore, is tinged with a bitter irony. His account of the closing stages of the Singapore battle with its stark military and civilian tragedy, followed by the desolation, disaster and disillusionment accompanying defeat, is very moving. His eventual destiny, along with 60,000 Allied survivors of the Japanese thrust into the Asian-Pacific area, was to be deployed onto the Thailand–Burma railway construction, a task said to claim 'a life for every sleeper'.

The horror, misery and squalor of life in construction camps, and in the jungle cities of sickness where those near to death were concentrated in what were euphemistically termed 'hospitals', are all recreated by his brush and pen. The ingenuity and improvisation of

prisoners in the jungle hospitals are captured by his phrase, 'corporate magic for survival'. His own artistry contributed to the extemporizing of stage and dress effects which helped lift 'shows' to a surprising professionalism.

The recognition of Jack Chalker's services as a war artist and medical illustrator emerged more officially after the Japanese surrender, when he worked with me at the medical headquarters of the Allied Staff in Bangkok, which dealt with the concentration and repatriation of surviving ex-prisoners of war. Those days of easy comradeship led to continued, I hope life-long, friendship, which has been renewed by more recent participation in sentimental journeys by POWs to war cemeteries, museums and the Memorial Walk at Hellfire Pass on the railway track in Thailand. As well, we exchange visits between our countries.

I commend Jack Chalker's book as an inspiring portrayal of the tragedy, heroism and ultimate triumph of surviving prisoners of the Japanese in the Second World War. His sensitive drawings and paintings have a unique value in documenting a conflict where photography was largely excluded. In addition to their great historical value, moreover, and despite the extreme difficulties of supply of paints and painting equipment, these illustrations reach a fine aesthetic level.

The author's gentle, modest, whimsical style belies his own gallantry, generosity, great talent, and extraordinary improvisation.

E. E. Dunlop

AC, KT, CMG, OBE, KCSJ,
MS, FRCS, FRACS, FACS,
DSc. Punjabi (Hon.) LLD Melb. (Hon.)
FCS Sri Lanka (Hon.), FRCS. Thailand (Hon.), FIC

PREAMBLE

THE DRAWINGS AND PAINTINGS in this book have been selected from many I made firstly as a gunner in the Royal Artillery in England throughout 1940-1, then in India in 1942, and subsequently as a prisoner of war under the Japanese for three and a half years.

After being concentrated at Changi in Singapore for a month or two I was moved to a labour camp in Singapore Town for four months where I began to make the first of the prison drawings. A few notes were made on the train journey up to Thailand and the remainder were produced in the jungle working camps and sick camps on the Thailand–Burma railway project during the last three years of captivity. After the Japanese surrender in August, 1945, I was attached to the Australian Army in Bangkok to complete official war records and during this time I produced further illustrations from notes made in the railway camps. Some of these have been included.

I managed to keep diary notes of our progress from the time we left England on our world trip to Singapore and subsequently during the fighting until we were captured in February, 1942. Thereafter as a prisoner of war I kept a microscopic diary which became intermittent after a move down-country from Kanyu to Chungkai sick camp in 1943. Some of these later diary notes were eaten by termites and rotted from the ravages of the monsoon rains. This account can only be a minute contribution to the overall complex and variable picture of conditions and attitudes that existed throughout the length of the Thailand–Burma railway. It is largely anecdotal, but it is told as I found it and remember it.

It is hoped that the drawings, paintings and hasty notes made under considerable difficulties and which had to be hidden throughout our prison existence may nevertheless give some idea of the conditions under which the Thailand–Burma railway was built and how we existed, together with an indication of the absorbingly beautiful jungle surroundings in which we lived during those curious years.

Over the post-war years I have been asked repeatedly why I made drawings and paintings in the camps, a question that never arose during our captivity. Visual curiosity, a delight in observation and in translating things in one's own terms is an inherent part of the ethos of an artist, and this drive, as well as pleasure in doing so, is undeniable. I began by making notes of places, people and landscapes to please myself, but it was not long before it became obvious that this was the only means of recording our strange circumstances. As conditions became rapidly more desperate in the jungle on the railway project it seemed imperative to record them, particularly the medical and surgical problems that faced the hard-pressed medical staff. I was asked by two eminent surgeons, Captain Markowitz and Colonel Dunlop, to assist in recording them and what had been largely a self-indulgent pleasure quickly became a challenge of far greater importance.

I count myself fortunate indeed that I was always fascinated by my surroundings and could find unending interest and delight in the Thai jungle. I am sure that such an interest played an important part in survival.

PRELUDE

IN THE EARLY summer of 1939 I was still a student and staying with my sister in her old Buckinghamshire house during a summer vacation and looking forward to taking up a post-graduate scholarship I had been awarded to the Royal College of Art in London in the School of Painting. Before the end of September my army call-up papers arrived, and I soon found myself in a regiment of field artillery, a bored and reluctant soldier. Having spent a good deal of time flying with my sister in old 'string-bag' Tiger Moths, I would have preferred to be an airman, but repeated applications for a transfer to the RAF were refused by the regimental hierarchy and like so many others I had to resign myself to the unending blancoing and boot polishing and the roaring of sergeant-majors. During the first six months boredom was relieved in part by a series of moves in which we drove about the southern countryside in rusting civilian vehicles reclaimed from scrapyards, including a 1920 'Guy' lorry, a battered removal van and an open Lagonda that had to be towed to start. We must have looked like a Fred Karno fairground convoy.

Our first two years of the war were spent in Britain. We moved about the country as truly English amateurs, guarding bits of coast with old French 75s and ancient First World War 18-pounders with defective elevating gear and breech blocks that jammed, while Hitler's Panzer divisions ploughed through Europe virtually unopposed. In the spring of 1940 we moved to Norfolk, and for the last three and a half months that we were there I spent the happiest period of our time in England living in the belfry of Swanton Morley Church, which was being used as an observation post overlooking a large bomber aerodrome about to be completed.

By the end of that year we were rearmed with the new 25-pounder guns, limbers and gun towers, and could appear to the outside world more like a fighting unit than a circus. We spent a few months in the lowlands of Scotland and elsewhere and finally moved south again to

billets in Stone, in Staffordshire, which for many was to be the last stop in England. There, in October, we were issued with tropical kit, given a short home leave, and on the 27th entrained for Liverpool where we were packed like sardines into an old liner, the *Orcades*, and lay at anchor mid-stream in the Mersey.

We set sail on the morning of 30 October in a convoy of seven ships with a naval escort, en route to Halifax, Nova Scotia. To our surprise we were met in mid-Atlantic by American warships and an aircraft carrier, the *Saratoga*, and were nursed safely by them for the remained of the journey. In Halifax we transferred to the USS *West Point*, America's latest luxury liner, hitherto the SS *America*, commissioned only in July, 1940, and handed to the navy a month later for conversion to a troop ship. Six thousand British troops were packed on board – the whole of the 55th Infantry Brigade.

We sailed on the morning of 10 November in convoy with five other troop-ships, under the protection of six American destroyers and two cruisers, and zigzagged our way down to Port of Spain, Trinidad. Here we spent a few days before moving down the South American coast and finally eastwards to Cape Town, where we arrived on 9 December. On our way to Trinidad the Americans put on an extravagant and hilarious 'Crossing the Line' ceremony in which many of us were involved and which I remember with great pleasure. War seemed very far away until at sea on 7 December we heard that the Japanese had attacked Pearl Harbor. America was at war.

At this point our American escort left us for more important business and we proceeded up the east coast of Africa through the Mozambique Channel to the Indian Ocean and Bombay, having our first Christmas at sea and arriving on 27 December. We spent two weeks in India. We had changed into tropical kit in mid-Atlantic, our large topees reminiscent of something worn at the relief of Mafeking. Some of this absurd headgear was consigned to the sea en route and later was dispensed with altogether in action in Malaya and Singapore. The Australian bush hat would have made far better sense. In India we spent our time polishing boots and blancoing belts to beyond

perfection, had *dhobi wallas* wash and press immaculate creases in our idiotic 'let-down' shorts, and attended endless futile parades without any preparation for the fighting that was to come. Our station was at Ahmednagar in the Deccan and the train journey there over the Western Ghats was magnificent and the country and its people enchanting.

By now the Japanese, who had landed in Malaya the day after Pearl Harbor, were pouring down the Malay Peninsula. We were rushed back to Bombay and the USS *West Point*, and left hastily for Singapore. We arrived there on Thursday 29 January, and our war began.

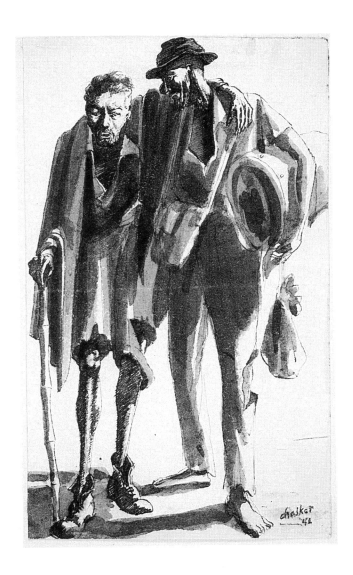

Working men, Kanyu Camp, October 1942: A pen and wash drawing made in Kanyu River Camp. One of two drawings of prisoners in the working camps to survive from a collection discovered by a Korean sentry. The remainder were savagely destroyed in an unpleasant situation.

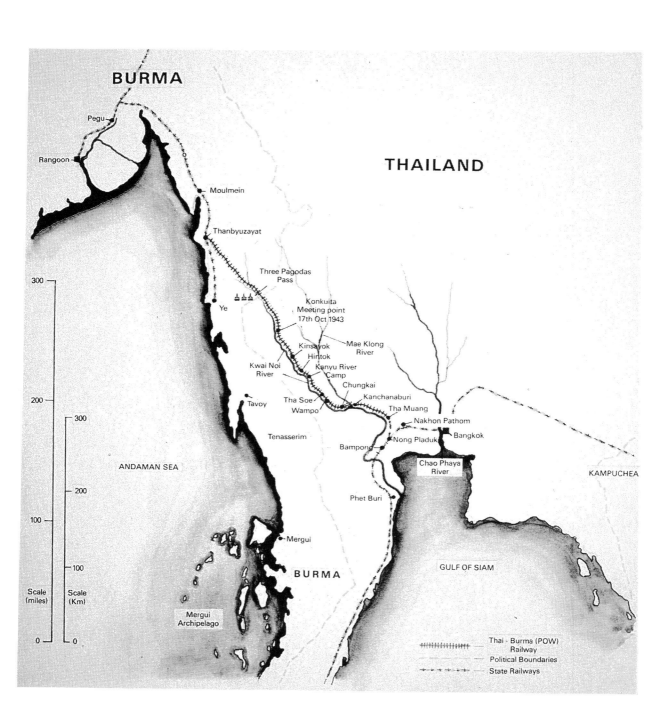

BURMA

Pegu

Rangoon

Moulmein

Thanbyuzayat

THAILAND

Three Pagodas
Pass

Konkuita
Meeting point
17th Oct 1943

Ye

Mae Klong
River

Kinsayok

Hintok

Kwai Noi
River

Kanyu River
Camp

Chungkai

Tha Soe

Kanchanaburi

Tavoy

Wampo

Tha Muang

ANDAMAN SEA

Tenasserim

Nakhon Pathom

Bampong

Nong Pladuk

Bangkok

Chao Phaya
River

KAMPUCHEA

Phet Buri

Mergui

GULF OF SIAM

BURMA

Scale
(miles)

Scale
(Km)

Mergui
Archipelago

300

200

100

300

200

100

300

200

100

0

0

+++++++++++ Thai - Burma (POW)
 Railway
---------- Political Boundaries
-·-·-·-·-·- State Railways

16

The Fall of Singapore

THE FIRST THING we noticed as we docked at Singapore was a huge sign warning BEWARE OF SHARKS, but our minds were quickly diverted from maritime dangers by one of the daily blanket raids by Japanese bombers on Keppel harbour. We said our goodbyes to our generous American hosts and disgorged ourselves from the ship in understandable haste.

Chaos and tragedy reigned at the docks as refugees of many nationalities packed the quayside hoping to leave by any vessel available. Children were crying and harassed mothers were trying to cope with a terrifying situation. Considerable damage had been done to the dock area and fires were burning in the wreckage. We moved from the docks to billets in unoccupied houses in Geylang, on the outskirts of the town, while our guns and equipment were unloaded from the ships. All about us distraught Chinese and Malays were attempting to uncover the remains of relatives from their bombed homes, and their agonized cries were harrowing.

Once our troop guns were available we moved to the north-east of the island on the edge of a rubber plantation and fired the first rounds from our 25-pounders up into the mainland. The Japanese were barely 8 miles away on the mainland. Our air support was non-existent and the Japanese were having it all their own way. The great naval base on the north of the island had been set on fire and its fuel tanks sent up a vast column of black, oily smoke which spread out as a great cloud above the island, blotting out the sun. The regular early-evening monsoon rain poured through this, collecting oily particles which covered us with thick, greasy filth that was hard to wash off. Civilians continued to flock to the harbour leaving their cars and possessions for anyone to take, and the relentless pattern-bombing continued to the despair of the unloading parties on the ships. Guns and equipment were lost, as well as men in the holds of the ships, and some units were left without weapons and ammunition.

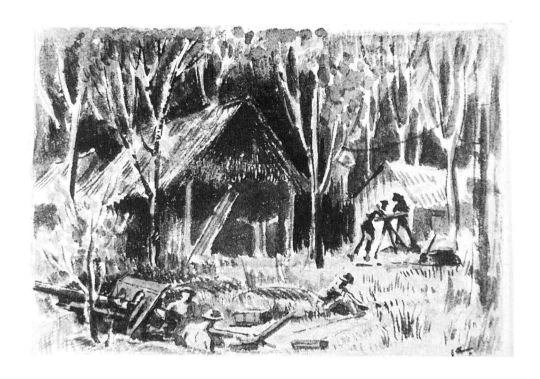

Singapore, February 1942: Our 25 pounder gun position situated in a rubber plantation.

The myth of Singapore as an impregnable fortress was rapidly destroyed, as the only preparation for its defence was a small collection of heavy guns on the southern side of Sentosa Island facing the sea. The military powers had assumed that an attack could only come from that quarter; plans had been discussed long before for beach defences on the south coast, but were never carried out. There were no deep air-raid shelters in the town and little, if any, preparation had

been made for the appalling situation that faced civilians and troops alike. Totally unrealistic written exhortations had been distributed to troops by Generals Wavell and Percival and Higher Command, and the situation was tragically pantomime. There were no defences at all on the north coast and only as a last resort was any attempt made to place tank obstacles on the vulnerable northern entrances. Even then, they were wrongly positioned. Later in the prison camps I learnt from members of the Malay Volunteer Regiment that the civil and military authorities had consistently ignored warnings over the previous ten years that Japanese fifth-column agents were setting up subversive units throughout Malaya and surveying jungle tracks.

The outcome of this military negligence was inevitable. On the night of 8–9 February, 1942, the Japanese attacked a sector on the north-west of the island held by the Australians, and after intense fighting quickly gained a foothold. Fifth-column activity was so well planned on the island that as soon as our signallers laid a cable from the guns to an observation post it would be cut into small pieces. Cattle were driven in a large V shape towards our gun positions whilst Japanese reconnaissance planes flew overhead. The enemy even used suicide observers in the baskets of balloons to transmit the locations of gun positions.

Of the fighting two strange memories stand out. The first occurred as I was on my way to an observation post on the outskirts of Singapore Town and had to make my way through a bombed house that was on fire. In a corridor I saw through the smoke and dust some brilliant colours on the floor. A small chest of drawers had been blown apart, spilling small skeins of brightly coloured Chinese embroidery silks and pieces of canvas. I stopped for a moment, caught by the beauty of the colours, and wrapped a handful of silks in a small piece of canvas and stuffed them into my pocket. They were to bring pleasure later on.

During the last phase of the fighting I was making my way back to our gun position with a Canadian soldier. We emerged from some scrub onto a bank high above a road that was being shelled, and below

us saw a small saloon car blazing fiercely with a pall of black smoke billowing above it into the trees. A young Malay woman in sarong and *kabaya* was running back and forth about it, crying piteously, and it was obvious that someone was still inside the vehicle. We scrambled quickly down the bank to help, but as we did so the woman, with a cry I will never forget, hurled herself into the furnace and was gone. The heat was intense and there was no way we could get into the blaze to assist. After a little while the car hulk shuddered and settled on the road with a shower of sparks and a small blackened arm appeared sticking out from a side window among the flames. We were near to tears at the sight of that funeral pyre and at our own helplessness.

By 15 February we had been pressed back into the town itself and were being shelled from all sides, including the sea. At 4 p.m. that day an ignominious surrender had to be made to the Japanese and the fighting ceased. The silence was very strange and a great relief. In ten weeks 60,000 tough, courageous and determined troops under General Yamashita had routed a British, Indian and Australian army of 130,000 men. It was hard to believe that we were now in Japanese hands.

Much has been written elsewhere about the indefensible complacency of the military and civil authorities in Singapore. The appalling and unnecessary losses of the courageous military personnel were compounded by the loss of so many thousands of innocent and vulnerable Chinese, Malays and other Asians. That night, as we wondered what the future held for us, we couldn't help but think of the 'Rape of Nanking' in December–January, 1937, when Hirohito's uncle, Asaka, together with Nakagima, the head of the Kempei-tai (the Military Police) deliberately organized 90,000 troops occupying Nanking to commit rape, murder, arson and theft on a grand scale in an attempt to achieve submission by Chiang Kai-shek. During six weeks of organized barbarity more than 100,000 Chinese women and girls were repeatedly raped, abused and killed. Some 200,000 men and boys were used for live bayonet and target practice, buried or burnt alive and subjected to elaborate multiple tortures. It should never be forgotten that Hirohito officially expressed his 'extreme satisfaction'

at the 'success' of this bestiality and added to his approval of it by presenting Asaka and Nakagima each with a pair of embossed silver vases to commemorate the business.

Our prospects were not encouraging, or in doubt from the time the hordes landed on the Malay Peninsula.

WE WERE CAPTURED by irregular troops and the first sight of our captors the following morning made an unpleasant impression. Ragged and with wounds roughly covered, they snatched rings and watches from prisoners, shouting and beating up in a frenzy of victory. The appearance of a Japanese officer put a temporary end to this looting and he dealt with offenders with great savagery. We were herded into large groups on the road and then marched off to join a rapidly growing column of prisoners at the southern end of the Bukit Timah road. After the inevitable waiting about and with what little we could carry, we were marched the 18 miles to Changi at the eastern tip of Singapore Island.

On the march we learnt of the massacre of patients and staff at Alexandra Hospital during the final phase of the fighting. Irregular troops had shot and wounded patients lying packed together in the beds and on the floor of the wards and had bayoneted medical staff in the operating theatre and elsewhere. Orderlies were taken outside to a shed, covered in petrol, set alight and then bayoneted to death.

In Changi, some of us were billeted in the married quarters of Roberts Barracks and a friend and I lived in the cupboard of an outside kitchen area. We had just enough room to sleep on the floor with our meagre possessions above our heads on a shelf. Food was extremely scarce and we began a semi-starvation period at once, existing on a hard biscuit or two a day and a mixture of musty broken rice impregnated with lime that had been intended for use as a fertilizer. This we consumed as a watery slop and on this diet became increasingly weak and shaky. Malaria and dysentery were already spreading and our meagre diet aggravated medical problems. The lack of food produced extensive vitamin deficiency with resultant oedema, beri-beri and pellagra, and prisoners began to die of starvation. Flies and heat added to the discomfort of the sick, and recovery from any illness become slower. We learnt to eat almost anything, some trying slugs

and beetles, and we looked upon the weevils in our rice as a good source of protein.

The makeshift hospital in barrack accommodation at Changi was packed to overflowing with wounded and others seriously ill with tropical diseases, and the meagre medical supplies had to be conserved with great care. Conditions were pitiful for the patients, packed together in great heat, even on the floor between and under the beds. The medical staff were worked to the limit and there was a desperate shortage of drinking water. One of our camp fatigue duties was to take bundles of blankets soaked with blood and faeces to a nearby beach and wade into the sea with them to remove as much as possible of the contents and then dry them in the sun.

Occasionally small groups were taken outside the camp boundaries on working parties to collect wood for the cookhouse fires and this enabled us to obtain scraps of food by bartering or stealing, as well as items of news that could be passed to us surreptitiously by local people.

From time to time lorryloads of Chinese men of all ages, roped together, passed us coming into the Changi area followed by the sound of machine-gun fire down by the shore. We realized that the Japanese had begun an extermination programme of Chinese civilians and Malays, as they had done earlier during the Sino-Japanese war. This was later confirmed by the increasing terror we witnessed outside the camp area when we tried to approach local people and also by my chance viewing of one of these massacres while on an outside working party.

On one of our forays for wood I noticed an exotic bungalow set in grounds sloping down to its own beach. Two of us managed to slip away from the guards and I entered the garden, which had been tended with great care and was full of flowers. Near the house was a deep pit littered with abandoned military equipment that led into an under-ground dug-out. The open entrance and its supports had been burnt black. I clambered down into the pit and approached the dug-out. The smell was appalling and I could just see a tumbled chaos of

blackened radio or radar instruments on the floor. Then I noticed other heavier shapes and became aware of the flies. There may have been two people in there, burnt black, and there was nothing to be done. I climbed out into the sunshine, the flowers and the fresh smell of the sea. We had seen it all before, but somehow the sickening contrasts in this quiet and lovely garden were particularly disturbing. The house had been ransacked and through the open front door I could see a pile of books and magazines thrown across the floor. Among these I saw a copy of one of my old school magazines and, strangely, in it was a notice of my brother's wedding earlier that year. I tucked the magazine into my shirt and managed to rejoin the working party unnoticed. It left a poignant memory.

The appalling conditions in Changi in no way dampened enterprise and ingenuity. Talks and lecture programmes were organized to occupy time and generate interest and quickly became a feature of many POW camps. Card schools flourished, as always, and a radio was set up underground amongst the latrines. A small concert party was formed and here I met Ronald Searle, who was drawing some of his early cats. A friend, a concert pianist, indulged me by playing Grieg and Mozart on an old upright piano in a bamboo and attap shelter. Morale was good despite the problems, and the daily crop of rumours provided food for discussion and conjecture. 'Free by Christmas' was the constant forecast of wishful thinkers.

There were some in Higher Command who attempted to impose tasks upon other ranks; these were ostensibly to alleviate boredom but were so puerile and irritating that they merely added to the misery rather than relieved it. Under these strange new conditions it was inevitable also that unpleasant and selfish attitudes would emerge. Minor rackets and swindles developed, largely associated with the need for food and survival, sometimes compounded by the abuse of rank.

In early May some of us were marched down to Havelock Road Labour Camp in Singapore Town where we were to operate as a 'hand-waggon' company clearing go-downs and working on a range

of labouring duties under Japanese and Korean guards. There were cases of extreme exhaustion and collapse on the march, but we met great kindness from the Chinese and Malay people, who passed us food and drink despite the efforts of the guards to prevent this. Our huts gave us about a yard of space apiece for living and sleeping, an improvement on the general conditions at Changi.

In Havelock Road our huts were attap-roofed and had planking in two tiers for living accommodation. They had been built by Malay war refugees to house prisoners of war. Food was better and with closer daily contact with local people, albeit haphazard, we could supplement our diet and felt less cut off from the outside world.

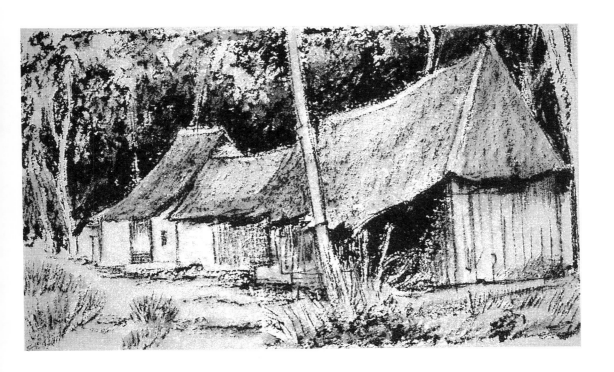

Singapore, 1942: Malay Kampong (original size 6cm x 3.5cm)

There were opportunities to scrounge or steal from wreckage and piles of waste, and to bargain for necessities. We also began to gear ourselves to the foibles and susceptibilities of our captors – not that we could do much with such savage and irrational overlords.

A friend, Graham Pettit, and I combined to increase comfort in our upper tier in the hut. We scrounged some old bits of canvas and a damaged car seat from a dump and raised the outer section of attap roof over our bed space to make a back entrance with a ladder of notched bamboo for easy access to the cooking area behind the hut. A car wheel-hub gleaned from one of our labouring ventures made an excellent frying pan. It seemed like luxury, but made no difference to the armies of bedbugs and lice with which the whole hut was infested and which were to remain our constant companions for our entire stay.

Despite these better conditions it was not long before diphtheria and food-poisoning added to our increasing medical problems, and numbers of sick men had to be moved back to Changi each week.

Many of the units within the Japanese Army were formed of Korean impressed troops, ordinary soldiers who were excluded from pro-motion. No doubt resentful of their humiliating status, these men could ease their constricted existence by wreaking every possible indignity and physical hurt upon prisoners in their charge. First class soldiers and above were all Japanese and all ranks were subject to harsh and immediate punishment from a superior for breaches of discipline, even to the point of being beaten to death. We witnessed this later up-country. These conditions had to be accepted as an integral part of our prison existence.

Bowing to all Japanese troops of whatever rank was mandatory, and if this was not performed well enough in the recipient's eyes the victim would be forced to stand to attention and be subjected to a bout of hoarse screaming and shouting, followed by continuous hard slapping or hitting in the face. This could develop into punching and kicking according to mood. It was never wise to remain on the ground

if knocked down during an extended bashing as this often promoted more advanced savagery.

There were some Sikhs in the Japanese-formed South East Asia Army and some of these changelings were put to guard us at Havelock Road. A few began homosexual assaults on POWs in the latrines at night and the whole camp rose up in anger. From then on nightly latrine-goers went in small fighting groups and the Sikh sentries henceforth kept well away from us. As an insult, the Japanese put Sikh sentries to guard a camp of loyal Gurkhas one night. The following morning not a Sikh could be found. It was not long before our own Sikh sentries were replaced with Korean or Japanese guards.

Our working day began soon after dawn. After a rice breakfast we attended the customary *tenko* (parade) followed by the long, boring routine of counting and allocation to work parties. We then marched to our work site pulling small two-wheeled handcarts on which the Japanese troops had dragged their kit all the way down the Malay Peninsula during the fighting. On occasion we were taken to fresh work sites on lorries. Working days were varied, sometimes carting stone in granite quarries, other days cutting pineapples in Johore Bahru on the far side of the causeway, trucking soil or rubble, or clearing dead bodies, wrecked buildings and go-downs. The work was not unduly hard. In this way we saw much of Singapore Town and its delightful population, by whom we were almost daily given little gifts of food and even money, always at great risk to themselves. We remember these courageous acts with gratitude.

I remember also one elderly Chinese lady who distributed small cakes to us one morning as we trailed past to a working site. The following day as she stood on the road to repeat this kindness she was viciously attacked and beaten by a Japanese *gunso*. The next day at the same place she appeared again, her face swollen and cut, limping out silently to us with more of her cakes. This lady was a symbol to many of us of the courage and fortitude of the Chinese people under

repression, and we were to witness much of this during our years as prisoners of war.

We remember the increasing bestiality of the Japanese towards the Chinese civilian population. All too frequently we passed tables set up at the roadside upon which were displayed severed Chinese heads, three or four at a time, covered in flies and with accompanying notices in Chinese and Malay. Often heads were displayed on bamboo poles. People were tortured in the streets, beheaded, shot or bayoneted to death and outside one of the *Kempei-tai* headquarters that we used to pass, half-butchered, half-alive victims could invariably be seen chained to or hanging from the railings. In the six weeks following the surrender the Japanese eliminated 7,000 Chinese, mostly men and boys, largely on the pretence of suspicion that they were members of the Kuomintang and working against the Japanese.

As a result of a few isolated attempts at escape, on Friday 4 September the 'Selerang Barracks Affair' began: 15,400 prisoners were herded into a barrack area built to accommodate a single battalion; they were held there for three days with little water, and many of them desperately sick, until agreement was reached that every POW would sign under pain of death a pledge not to escape captivity. All POWs had to comply.

We were usually back from the working sites before nightfall. Wherever we worked we kept an eye open for anything useful that could be brought back and this sometimes necessitated a little group organization to mob the guards who were watching for contraband as we came back through the gate into camp. Our evening *tenko* was taken by the Japanese Commandant complete with his Samurai sword and standing on a box to make his short presence more imposing. When the counts were at last completed and the Commandant dismissed us we were expected to bow and shout *wackari*. This we immediately changed to 'buggery', which delivered in chorus sounded much the same and gave us the advantage in insults.

In the early days, without interpreters, we amused ourselves at the guards' expense. When they asked us the English word for some

Singapore Town, 1942: Incident observed whilst on a working party; Japanese beating a man's hands to pulp with a lump hammer on the stump of a tree for stealing from a Japanese store place.

simple object such as a 'boot' we would give them a word such as 'shit'. The sentry would then display his new-found knowledge on every occasion. Pointing to a prisoner's pair of boots he would say, 'You solja, you number-one shit-ga', indicating that he thought the prisoner had a first-class pair of boots. The game extended into our numbering on parade, inserting 'Jack, Queen, King' for eleven, twelve and thirteen, and gave us constant enjoyment until the guards cottoned on. From then on this was savagely suppressed and we had to obey all orders and number up to 1,000 in Japanese. We continued to enjoy producing appropriate nicknames for the guards, nevertheless. One of these was a generous little Korean, not much more than 4 feet 6 inches high, with huge feet encased in black, canvas-topped regulation boots with the big toes separated from the rest. We called him 'Donald Duck' to his face, which he always took in good part. Another, 'Amasaki', the schoolmaster, made our lives as tolerable as he could and we were grateful to these two men. Most guards ranged from the barely tolerable to the bestial. More typical were 'Blood-Pressure', who was in the habit of working himself up to a screaming frenzy before setting about us with his fists and feet; 'Laughing Boy', because he never did; and 'Hockey Stick', who always carried one about with him and used it frequently. 'You Go Halt' was fond of this term to describe a prisoner who was not working; 'Jungle Princess' was a hideous character with badly protruding teeth; and 'the Undertaker' was a gloomy, sullen basher who rarely spoke.

One of the early sites we were taken to for work was a tennis club on the outskirts of Singapore Town where a large petrol dump was being formed. Lorryloads of large metal drums were being brought there from various parts of the island and our job was to unload these and pile them in rows three drums high on the club fields. I had with me a large jack-knife which the Japanese had not yet found among my possessions. It sported a marlin spike and with this we managed to puncture every third drum whilst stacking. The increasing stench of petrol did not seem to worry the guards and we made sure that there was no smoking during our *yasumi* periods. We spent two days

there spiking the drums without the guards catching on. It was fortunate that we were then transferred and never visited that site again.

On another occasion, while working at Alexandra Hospital, a 20-foot high bank we were digging away suddenly collapsed and two of our number were buried. 'Hockey Stick' and other guards worked with us in a frenzied effort to save them and it was encouraging to find that some guards at least had a veneer of compassion. Sadly, both men had died before we could get them out.

We were a mixed bag at Havelock Road Camp, from all units of the army together with a number of men from the Malay Volunteer Regiment who had until the outbreak of war been civilian rubber planters, tin-mining experts, scientists and specialists in other fields. From them we learnt much about Malaya and its people. One was a most interesting man who had lived with the Sakai people in the jungles of central Malaya and whose tales were absorbing.

Lectures were organized on a multiplicity of subjects, along with the card and bridge schools that had been part of everyday life since we had entered the camp. Despite the restrictions there was much laughter and great companionship and we learnt a great deal from each other. I found time to make some drawings of the conditions in which we lived and worked; at that time it was not forbidden, as it was later in Thailand. I also had a few small portrait commissions from fellow prisoners and with a few pastels I had found amongst some rubbish I produced some pin-up ladies for the hut. I designed a small satirical 'crest' as a small pen-and-wash drawing to which I added the appropriate Latin motto, *In excrementum tauri non fidemus*, which I hoped was close enough to translate into 'we have no faith in bullshit'. I had a number of orders for this.

Not long before we left this camp we were taken on one of our daily working jobs to tidy up some go-downs in town, into which a large body of Japanese officers and men were to be billeted. They were coming down from Kuala Lumpur and were due in a few days. The same night we collected every bedbug, louse, scorpion and

crawling insect that we could lay our hands on and the following day, armed with full tins we infested those go-downs with great enthusiasm. The guards, under the illusion that we were working energetically, gave us extra *yasumi* time for our good will. We left with our tins empty and felt that we had at least shared something with our captors.

Scraps of news filtered through to us occasionally from outside contacts, but great care had to be taken over news distribution to maintain secrecy. Conversations overheard by the guards might lead to the discovery of a radio or any other source of outside information and the Japanese were well aware of this. The penalty for being found with a radio or even a news contact was as severe as any, but there were some courageous men who kept a radio throughout. Some were caught and disappeared, others were tortured but survived, and some managed to live with the tension of keeping one without discovery.

From time to time whilst working in the town we were able to pick up copies of newspapers such as the *Singapore Times*, renamed the *Syonan Times* by the Japanese. In a copy of one of these I found two reports which were so ludicrous that they are unforgettable. Both were accounts of the bravery of intrepid Japanese pilots. The first told of a pilot who, having run out of ammunition, was being chased by enemy planes. With great presence of mind he opened his cockpit cover and hurled his rice-ball at his enemy, who, thinking that this was a grenade, immediately called off the chase. The second was the account of an equally intrepid pilot who also had run out of ammunition and was being harassed by enemy planes. Sliding back his cockpit cover he drew his Samurai sword and banking his plane, cut off the wing of his opponent's aircraft. Both pilots were awarded the 'Order of the Golden Kite'. I kept this cutting until it was eaten by termites some months later.

In early September we heard rumours from Malayan contacts that the Japanese were preparing to construct a railway somewhere in Siam, as Thailand was then called, and that prisoners were to be employed on the project. At the end of that month there was an issue of Red Cross foodstuffs and we ate bread for the first and only time

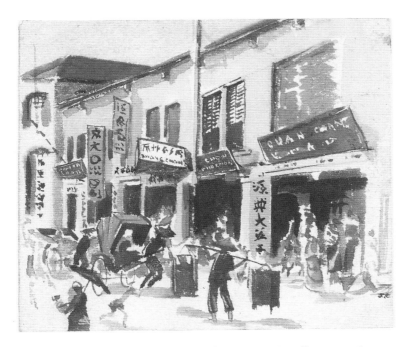

Singapore Town, February 1942: Chinatown. Small watercolour
note (original size 10cm x 2.5cm approximately).

Singapore, May 1942: Havelock Road Labour Camp. Pen and wash
sketch of the interior of my hut.

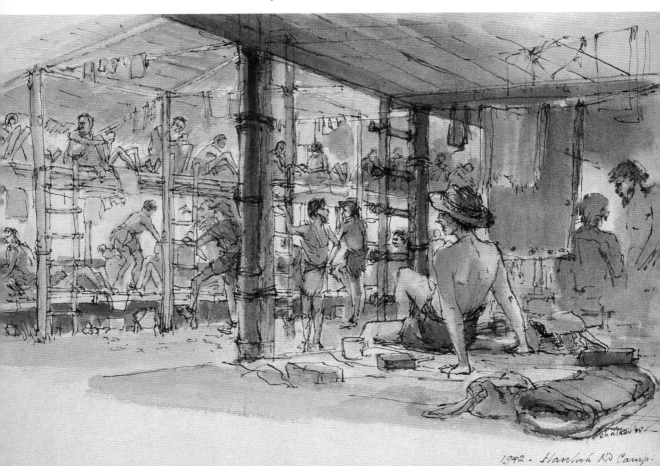

1942 - Havelock Rd Camp.

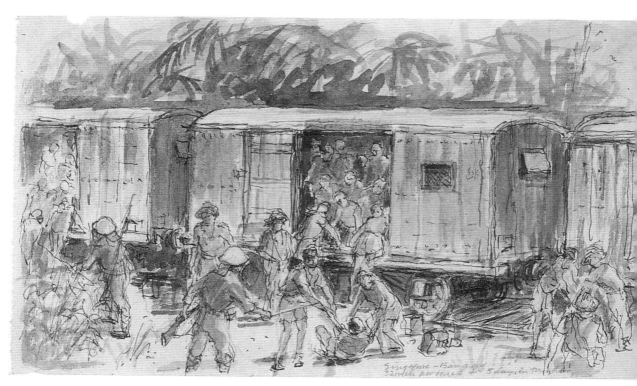

Singapore — Thailand, October 1942: Pen and wash note of the five day train journey from Singapore to Bampong in Thailand. Thirty-two men crammed into each metal box-truck with room only for a small number of men to sit at any one time.

Thailand, October 1942: Kanchanaburi, the confluence of the Kwai Noi and Mae Klong rivers. Watercolour note made on the march up-country. From here northwards the country becomes mountainous and is covered in thick sub-tropical rain forest.

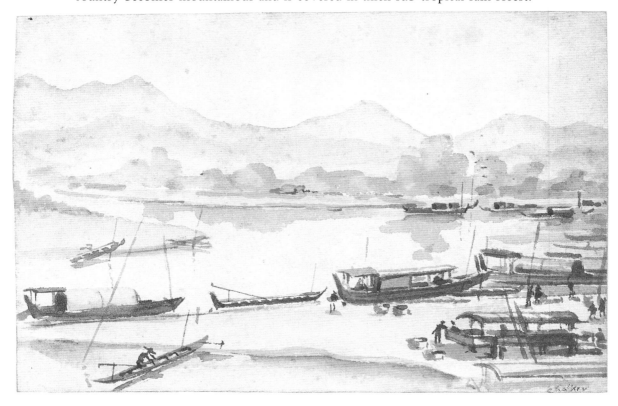

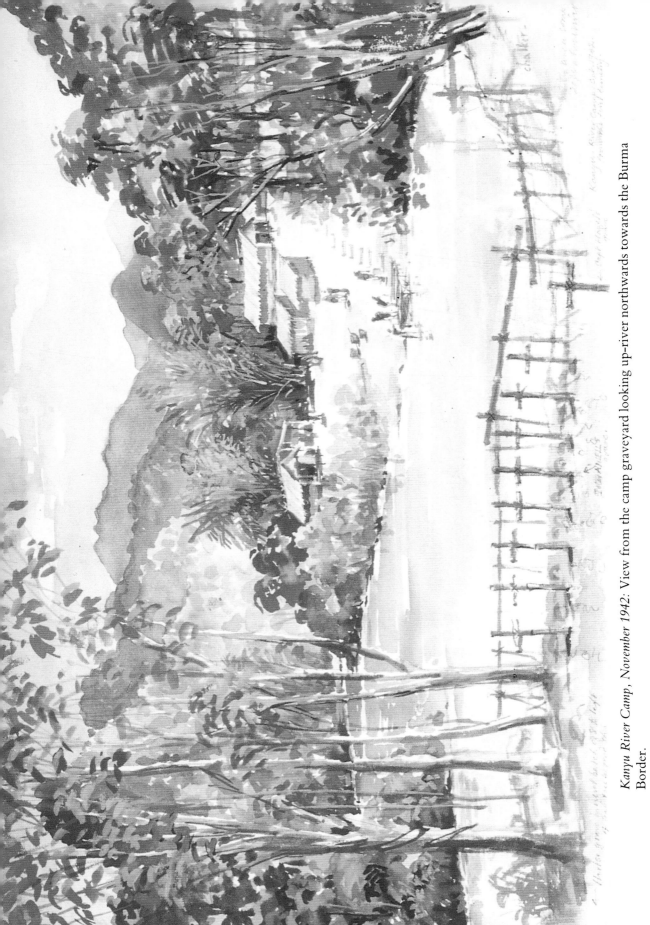

Kanyu River Camp, November 1942: View from the camp graveyard looking up-river northwards towards the Burma Border.

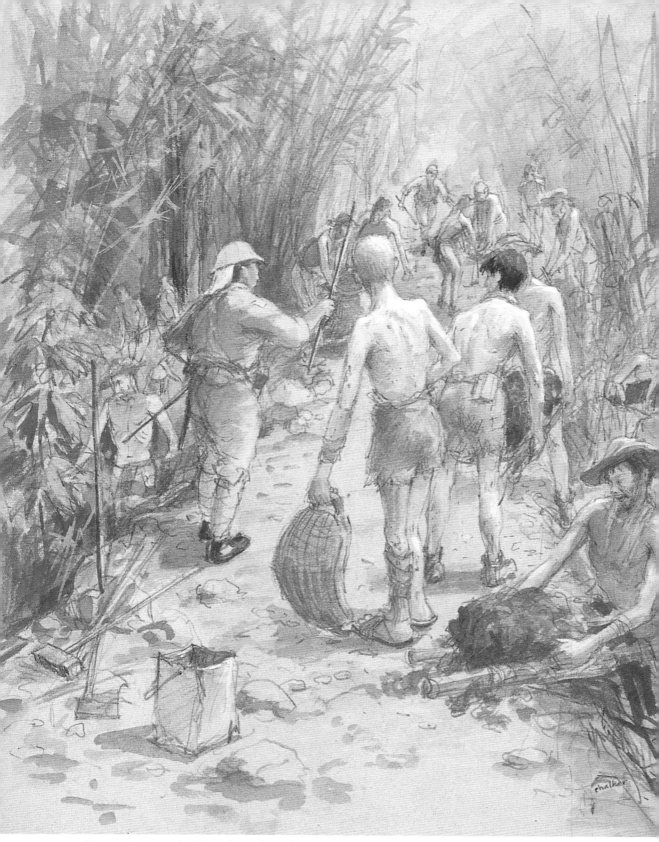

Kanyu Camp — building the railway bund: Watercolour showing prisoners clearing jungle and constructing the railway bund, or embankment, with rocks and earth, under supervision of Japanese engineers and Korean guards.

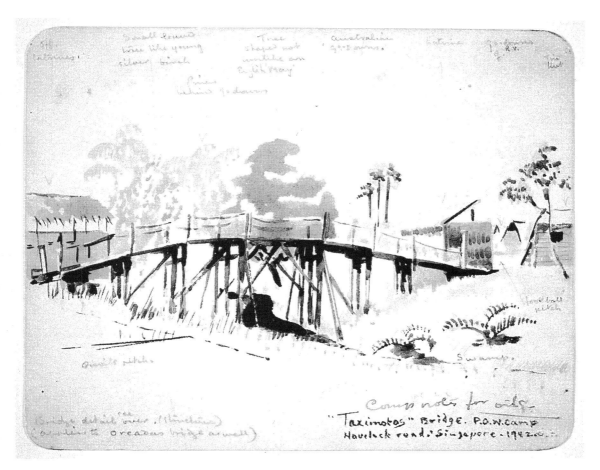

Singapore Town, 1942: 'Taximoto's Bridge' across a mangrove swamp at Havelock Labour Camp.

during our captivity. For a few days we lived relatively well, but were warned to prepare for a move within a week.

The Japanese were by then fighting on the borders of India and needed a supply line overland from Bangkok to Rangoon to support their northern front in Burma. The sea route around Singapore and north to Rangoon was long and vulnerable to submarine attack. The proposed rail route led north from Ban Pong, a railhead some 50

miles west of Bangkok, up to Kanchanaburi, a small town at the confluence of two rivers – the Mae Klong (or Kwai Yai) flowing from the north and east, and the Kwai Noi west of this running north–south within the hills of the Tenasserim border. At this point a substantial bridge would have to be built and the railway would then run northwards through the jungle-covered hills to the Three Pagodas Pass at the Burma border. It would then continue on through Burma to meet the existing Ye–Moulmein railway at Thanbyuzayat. This was a distance of 250 miles through difficult mountainous country covered in dense sub-tropical rainforest, an area of endemic malaria, dysentery and cholera and subject to the ravages of the monsoon between May and October each year.

Some 60,000 British, Australian and Dutch Colonial troops, as well as some American POWs, were to be employed on the project as an expendable labour force. They were to be divided into ten groups with two auxiliary units, 'F' and 'H' Forces, under Malayan control. In addition, some 200,000 Asian workers – Chinese, Malay, Tamil, Thai and Burmese – were coerced into joining the scheme under the direct control of Japanese guards. In charge of the whole operation was the Japanese 9th Railway Regiment, assisted by Korean and Japanese guards whose primary function was to organize and supervise the working camps. The Japanese engineers had estimated that the 1-metre gauge railway could be built in fourteen months from scratch and Japanese Higher Command stipulated that the project should be completed by the end of December, 1943.

The work was to begin at each end of the proposed railway and work towards the middle, with the labour force distributed along the route, clearing jungle, building embankments, bridges and hacking immense cuttings through the limestone hills in preparation for the line-laying gangs following up. In all, seventy-two camps were set up between Ban Pong and Moulmein, with an additional ten on a branch line between Thanbyuzayat and Ye, and 688 bridges had to be built over culverts and along the steep hillsides to carry the 250 miles of track.

OCTOBER 1942

The train to Thailand and the march up-country

THURSDAY 15 OCTOBER found us lined up on Singapore Central Station platform after a tiring march. We were prodded, thirty-two at a time, into closed metal-box trucks with sliding doors. I had wrapped my small supply of watercolours in a scrap of old gas-cape which I had fashioned into a large envelope. With it were two brushes, a few fine drawing nibs and some Chinese stick ink.

In the railway wagons we were jammed together with our kit piled high in one corner. The journey lasted five days and nights, and it seemed like weeks. Our wood-burning engine hauled us via Bukit Timah, over the Causeway to Johore Bahru and onwards, stopping at Segamat in the dark where we could hear the monkeys chattering in the trees. Then on to Gemas, arriving at dawn in Tampin with a soft mist over the jungle. I remember a later stop at Kendong, a pretty little station full of exquisite flowers. It was a brilliantly sunny and very hot day and we could see Malay families in the padi fields ploughing with water buffalo, tiny children riding on the backs of these huge, long-horned beasts with a great vista of blue hills rising from the mist beyond. The Malays waved and gave us a V sign and we were grateful for this friendly gesture.

We reached Seremban at noon the next day, moving into more hilly country, climbing gradually past open tin mines and arriving in Kuala Lumpur at midday. Here we were emptied onto the station, an immense, enchanting building like a sultan's palace covered in delicate minarets and threaded with decorated arches, gleaming white in the hot sun. We were served with cocoa from our Red Cross rations, and with rice. I helped a fellow prisoner re-wrap a small radio and tuck it more securely into his pack. I was relieved when the thing was comfortably out of sight.

All too soon we were shouted back into our black holes and jerked onwards through countryside full of birds and flowers to Tanjong Malim, soon arriving at Slim River. Here the place was strewn with

the wreckage of war: it even still seemed to smell of it and I made a small sketch there. Ipoh had a fine station and we had a chance to walk about there among a large number of Tamils sleeping on benches and all over the station platforms.

From Bukit Mertajam we moved northwards through Kedah and miles of *padi*. The Malay houses were built on stilts and in the distance were great peaks of tree-covered rocks jutting suddenly out of the flat landscape. It rained there and the cool was refreshing.

At last, beyond Padang Besar, we crossed the frontier into Thailand on the Isthmus of Kra. Thai officials appeared dressed in semi-Americanized uniforms, Buddhist priests in saffron robes watched us go by and we had our first sight of Thai money. By now we must have stunk and some of us stood under a water tower at a siding, revelling in a cascade of rusty water. After steaming off in the sun we rolled luxuriously on a grass verge and stretched the cramp out of ourselves. From time to time we persuaded the engine drivers to give us some hot water from the release valve of the engine to drink and to mix with food; although oily, it seemed a bonus.

We were allowed another two-hour break at Chumphon. We bought pomeloes and mangoes from two lovely Thai girls, and I killed a snake. Six elephants with two young passed us, their oozies sitting on their heads, and gibbons called in surrounding trees. Despite our miserable conditions, the changing landscape – what we could see of it – was full of interest and great beauty.

Just after dawn on 19 October we arrived at our destination, Ban Pong. We stood between the railway tracks with our kit about us while the guards rushed up and down our lines shouting and hitting us in an exaggerated attempt to create order before their usual counting. One prisoner, foolishly, had smuggled a small puppy from Singapore. A sentry saw it and snatched the animal, threw it on the ground and bayoneted it to death, screaming all the time at the soldier. It was not an encouraging arrival.

We were marched off through the town to a camp about half a mile away. As in Malaya, the streets were lined with small open-fronted

shops and stalls bearing bright signs in Thai and Chinese. The people watched us silently and curiously, but they seemed friendly and compassionate. We were a sorry lot, tired, filthy and some very sick, and the Japanese enjoyed their supremacy and made the most of it in front of an audience.

Ban Pong Camp was a collection of dilapidated bamboo and attap huts leaning drunkenly in a sea of mud and water from the monsoon rains. Its boundary was marked with a high bamboo fence. At the entrance was a guardhouse filled with a collection of scraggy, ill-dressed dwarfs, bayonets fixed, all set to wade into the new arrivals at the first opportunity.

The place stank in the steamy heat; the Japanese here had little concern for sanitary or other arrangements. The hut to which I was allocated had once had bamboo racking on which to sleep, but most of it had collapsed onto the waterlogged ground. On the section still intact we found a number of very sick men, the remnants of a former party suffering from a range of serious illnesses and without any medical help. Some were completely immobilized and others were shaking with malarial rigors. Everywhere faeces were floating in the pools of water and the whole place was extremely depressing. Food here was equally appalling. We were given some sour and almost cold rice and vegetable water, and spent a loathsome night propped on whatever bits of bamboo support we could rig to avoid sleeping in the faeces-laden pools. We were relieved to leave that place early the next morning.

Opposite the guardhouse a young Thai was tied to a post. Around his neck, hung with a wire handle, was a ragged-edged, 2-gallon metal container half-filled with water. He was in great distress and clearly the Japanese intended to torture him further. Suddenly another young Thai rushed into the camp past the sentry, slashed the victim free with a *parang* and pulled the wire handle over his head. Together they rushed the advancing sentry and much to our relief escaped into the trees beyond. The sentries poured out of the guardhouse like angry wasps, screaming and rushing about impotently outside the perimeter

fence. Seeing us watching, they turned their attention on us and indulged in some face-hitting to let off steam.

Our few carefully conserved Red Cross rations were life-savers on the long unhappy marches up-country upon which we now embarked.

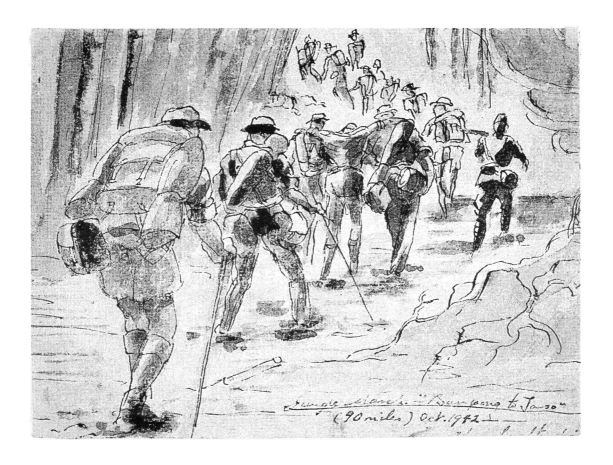

Thailand, October 1942: Beginning of the march up-country; exhaustion and little food, combined with the tail end of the monsoon, made it impossible to carry anything but the bare essentials and much of the kit had to be jettisoned very early into the trek northwards.

My memories are of great weariness. We threw away everything except our most precious possessions. My few watercolours and some scraps of paper remained among the meagre belongings in my haversack and were surviving the unending wet and devilry of the monsoon.

We trudged northwards across a vast area of rice *sawas* in the flatlands towards the foothills of the mountains bordering Tenasserim, dragging ourselves along the tops of the narrow separating banks which were sodden with monsoon rains and broke down easily underfoot. The tiny mud banks quickly became slimy, pointed ridges from which all but a few slid down on one side or the other into the water of the *sawa*. After a while it didn't seem to matter, for we were soaked to the skin and exhausted from lack of food and sleep and harassment by the guards.

Towards the end of the first day's march we reached a road lined with lime trees and flowers and were able to pick some limes and add their juice to the water in our bottles. Thai villagers came to us with fruit and drinks and some small cooked eggs wrapped daintily in banana leaf. They were unforgettably kind and their actions no doubt saved many from complete collapse. Those who collapsed had to be left by the roadside and were tormented by guards or picked up within the next few days by carts or lorries carrying Japanese stores. At one point we stripped off our clothes regardless of passers-by and lay in a small stream beside the road to cool down. Of the 500 who had started out that morning about sixty of us arrived at the next staging point.

Next morning we left at daybreak and dragged ourselves, with continuously depleting numbers, a further 12 miles to the confluence of the Mae Klong and the Kwai Noi, at the small town of Kanchanaburi. Here we were dumped on an expanse of green near the rivers in a most beautiful setting, with mountains to the north and west; some of us just lay on the ground and took it all in. As we rested, the usual six o'clock monsoon storm clouds gathered to the south and the strange preceding violent wind began to stir the palm fronds. The clouds rapidly became blue-black and raced towards us to deliver their early evening deluge. We began to watch and from out of a deep red

hole in the middle of the seething cloud mass came continuous streaks of forked lightning, and we were given a display like something from an illustration to the *Arabian Nights* or 'The Ride of the Valkyrie'. We slept out in great pools of water; there was no cover and it seemed very cold that night. By the morning faeces were everywhere, but by now this filthy situation seemed almost normal. In any case, we were far too exhausted to be bothered by it.

At daybreak, after an issue of rice, we were ferried across the Mae Klong and plunged at once into thick jungle. The sun rose quickly, as always, and steamed off our soaked clothes, giving momentary comfort before its full heat roasted us once again. We began to march northwards along the eastern side of the Kwai Noi, moving along small tracks running north-south. The monsoon rains had worn deep gullies from the tops of the hills down to the river below and as we traversed one of these immense culverts in thick jungle we stumbled through a shimmering mist of thousands of exquisite swallow-tail butterflies, completely filling the gully as far as one could see. It was an enchantment in the midst of wretchedness.

Our next staging place was also in a tranquil and most beautiful setting beside the Kwai Noi, later to be the site of a large working camp. We arrived in bad shape and rest was denied us by the Japanese Commandant, Kokabu. We were to meet him again a year or so later in a camp up-country. We were given sour rice which was inedible and had already been rejected by the party before us. Because we refused to eat it, Kokabu paraded us continuously throughout the night to ensure we had no rest. There were endless roll-calls during which he strode up and down our lines in torrential rain, roaring and waving his short, unsheathed Samurai sword and slashing one collapsing prisoner.

We stood most of that night in deep pools of water, soaked to the skin and very cold. When we returned to our attap shelters in the early morning many found that their last precious possessions had been rifled by Thai locals. By good fortune I found my haversack untouched and my paints intact.

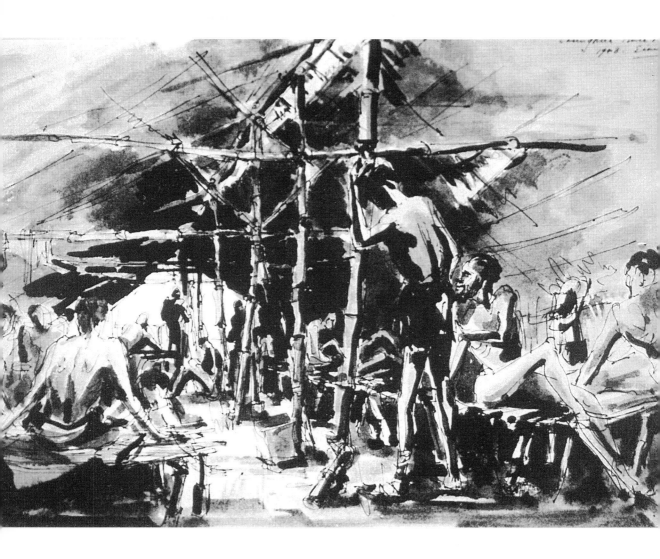

Living accommodation on the railway trace: Pen and wash drawing of my hut interior, typical of of the bamboo and atap huts in which all prisoners lived on railway work. We lived on bamboo racks with about one metre per man of bed space. The bamboo was riddled with bed-bugs and in the monsoon season water poured across the ground under the racks and through the attap palm roof.

As it began to get light we left that place and Kokabu to face the worst day of the march up-country. The lack of food and rest had taken its toll and the 15-mile trek over increasingly difficult hillside tracks was a nightmare. Many collapsed and had to be left where they fell or be helped to limp along, sharing each other's kit in turn. There were no generous Thais to offer us food or water. We were not yet initiated into jungle existence and that part of the journey proved fatal for a number of sick prisoners.

It was dark before we arrived at the next staging point, where we were ferried in the dark over a culvert on a flat raft pulled by ropes. We were too tired to notice what was happening and I have no idea where the place was. We lay down on the far side in a marshy jungle clearing after building fires for light and warmth, but ended up once again sleeping in muddy pools wherever we could find a space to drop. Next morning there was some excitement over fresh tiger pug-marks tracking right through the middle of us.

It was here that I first noticed the prolific orchids and passion-flowers, and – less common – the scarlet hibiscus, that grew throughout the jungle. Hornbills called and occasionally high in the teak and kapok trees I could catch sight of wild fowl with long, brightly coloured tails.

At night we slept in a mist of mosquitoes. Each day malaria and dengue fever claimed fresh victims who shook with rigors and had to be left shivering and often delirious beside the track. Some hot pig-and-marrow water – for it could hardly be called soup – was issued to us with our rice that morning and we started off again along a track leading to higher ground. Despite the rocks and small boulders it was better going than during the previous few days and we quickly dried off in the sun. Now we could see through the gaps in the dense foliage something of the majesty of the jungle-covered hills and the rugged, strangely shaped peaks to the north. These hills formed the formidable Tenasserim border and were the tail-end of the Himalayas.

In the last day's march we negotiated a further 12 miles in fierce heat. We arrived at a site, soon to be developed as Tarsau Camp,

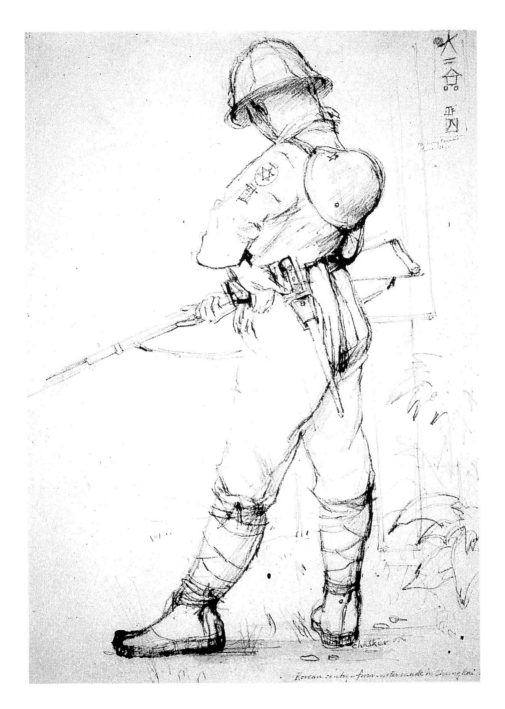

Singapore , 1942: Japanese sentry.

Kanyu River Camp, November 1942: The view is from the river's edge and shows the cookhouse on the left.

Kanyu River Camp, November 1942: Pen drawing of entrance to graveyard high above the river.

where some huts offered the possibility of shelter for a few hours, but they were occupied and so once again we settled ourselves in the open at the edge of the jungle. We built a fire and slept dry for the first time in ages.

To our great relief there were no marching orders the following morning and we had our first chance to rest. We were given some reasonably well-cooked rice and vegetable water and then wandered about the clearing looking at our surroundings. We had a soothing

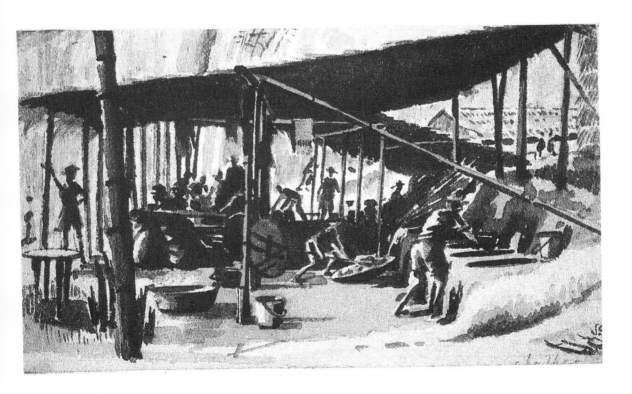

Kanyu River Camp, November 1942: Wash drawing of cookhouse showing kwalis set into mud bank, above fires, in which rice was cooked. Bamboo and attap shelter.

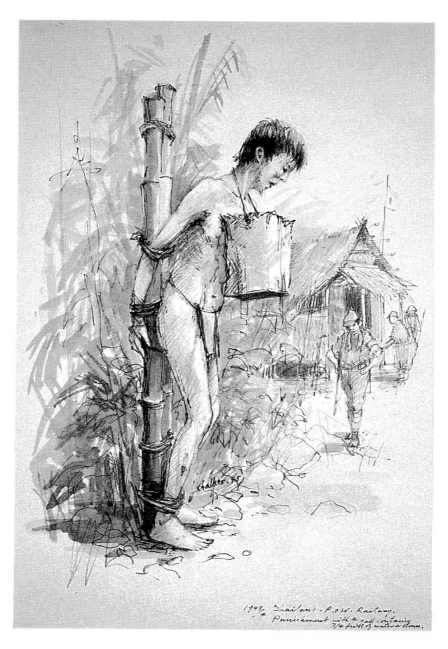

Punishment for more serious offenses: The tin container was filled with stones or water, when the neck was straightend the jagged edge of the tin lacerated the chest. It was a form of punishment used more frequently against Chinese, Thais and other Asians.

46

swim, the first of many in the Kwai, and sat on the bank watching the large blue kingfishers diving for food and the gibbons swinging through the trees on the far side, whooping and chattering as they went. A column of immense red ants discovered us and when we pulled them off our legs their heads remained attached to their strong

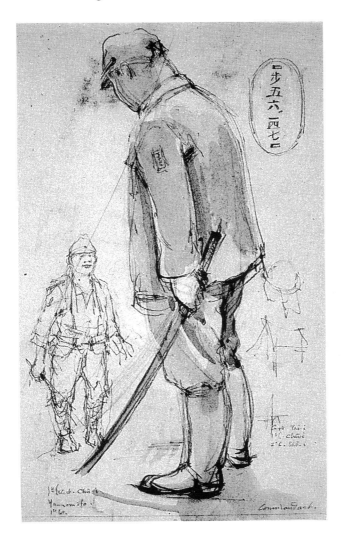

Chungki 1942: Japanese commandant and Korean sentry.

47

mandibles embedded in our flesh. We cut bamboo for the cookhouse fires. I caught another snake to eat that evening.

The following day, in drizzling rain, we were packed into one of the long teak rivercraft with a Jap sentry and a group of Thai boatmen and were towed slowly up-river by a small diesel-powered launch called, onomatopoeically, a *pom-pom*. Our progress was slow as the great river was still being fed by the monsoon rains from the hills, but it gave us welcome time to observe the beautiful changing scenery. It was a journey full of wonder and interest. In places the Kwai Noi had worn deep gorges in the limestone, sometimes 100 feet or more,

Thai — Burmese bullock carts: Pencil drawings done on the back of Japanese army postcards.

leaving strange masses of water-sculpted rocks topped with large trees, their roots woven into the rock-face like massive tangled snakes. White ibis flew beside us low above the water and other brightly coloured birds could occasionally be seen high among the foliage of the taller trees. At one point we saw Thais building immense bamboo rafts to float downstream. Late in the afternoon we landed at a small clearing on the eastern bank of the river beside a steep mountain rising immediately behind it. It was Wednesday, 29 October, 1942, and the place was Kanyu River Camp.

Some *kwalis* (large metal cooking bowls) and meagre rice stores

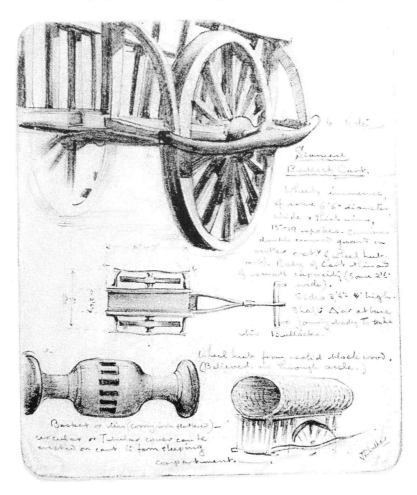

were unloaded, together with our kit, and we dumped ourselves at the upper edge of the clearing against a wall of dense jungle and built a fire. It was drizzling with rain and although we were due to spend yet another night in the open we were at least a little rested and had the time and energy to rig ourselves some primitive comforts. There were two low bamboo and attap huts occupied by Japanese in the clearing and we were informed that our first job would be to clear a wider area and build additional huts before starting work on the railway site 2,000 feet above us in the hills. Food was sparse and we became ravenously hungry. We managed to catch another snake and this partly appeased our gnawing hunger.

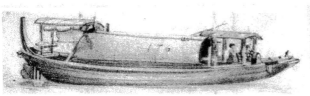 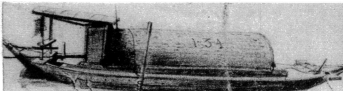

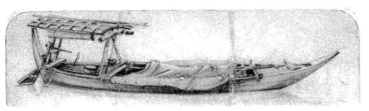 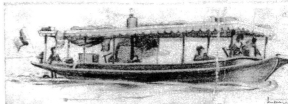

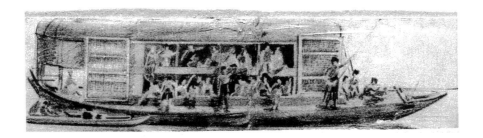

Kanyu River Camp, 1942: Various types of river craft operating in our vicinity.

OCTOBER 1942 – MARCH 1943

Kanyu River Railway Camp

I SPENT ALMOST six months at Kanyu River camp, working on the railway project. Early days were spent cutting bamboo, unloading attap palm from the riverboats, constructing new huts and clearing a large area of jungle to extend the camp. We left the giant teak and kapok trees standing, with their lianas and other thick creepers hanging about them like rush skirts.

A few days after our arrival in Kanyu one of our number – the first of many – died from diphtheria on his twenty-first birthday. We buried him in a small clearing a little down-river, in a beautiful site with a magnificent view northward to the ranges of hills leading to the Burma border. This isolated area rapidly became a full-scale graveyard and the bamboo crosses increased daily. Here at the edge of the clearing above the river, encircled by thick creepers and ropes of lianas, a huge teak tree grew not far from a large limestone boulder. Later on, someone made a small bamboo altar about this stone and it stayed as a memorial to those who had not survived.

We buried our friends and fellow prisoners quite simply, in shallow graves, the emaciated bodies crudely sewn into rice sacks. Somehow these small ceremonies with friends transcended the elaborate ritual of Western funerals. Although religious ceremonies were allowed and were used during burials, formal religion had little appeal in our camps as few could associate any divine providence with the unending daily carnage. Courage, laughter and practicality became our passports to survival.

About a week after our arrival the Japanese began transferring groups of prisoners to work on the railway site high above the camp. The 'speedo' phase was now under way, an inhuman drive by the Japanese to complete the project within a year. Prisoners from Java and Singapore were rushed to Thailand and a large party of Australians was shipped to Moulmein from Java to construct the track from Thanbyuzayat southwards through Burma. Added to this was a large impressed

51

work force of Asians, without authoritative support or medical attention, who were soon dying by the hundreds. Their conditions were pitiful in the extreme and they were subjected to horrific brutality. Dutch Colonial troops from Java were added to the labour force, which included a number of Dutch-Javanese Eurasians from whom we learnt much about Indonesia and its culture.

Building a track through the jungle-covered hills involved the construction of huge bunds or embankments, a great many bridges over ravines and culverts and long, immensely difficult cuttings through hard rock with primitive tools. This would have been a Herculean task even with the use of sophisticated machinery – when it had been considered some years earlier by an international group of engineers it had been pronounced impracticable and far too great a risk for human life – but with an expendable labour force available the Japanese were determined to achieve the impossible and their success in the Burma campaign may well have depended upon it

Work on the railway track was apportioned on a task basis, each group having a certain amount to complete within a set period – so many yards of bund to build or area of jungle to clear, so much earth or rock to move or depth of rock to break out and clear. Work was indicated with markers and the guards saw to its completion, often with the savage use of a bamboo shaft or, in the case of the Japanese engineers, an iron bar 4 foot long. Prisoners were kept at work until the allotted task had been completed, and this could be anything up to eighteen hours or more. Many POWs were without boots and working on splintered rock severely injured their feet, frequently leading to tropical ulcers.

During the monsoon, working conditions were particularly bad. There were days of torrential rain, and storms that turned the camps and railway site into a quagmire and made the steep climb up the hillside even more exhausting. Attap roofing was repeatedly torn away by the wind and one night a great tree was blown down across one of the huts. The river could rise 6 feet in a day, with trees and other debris whirling down in the boiling current. It was during the monsoon

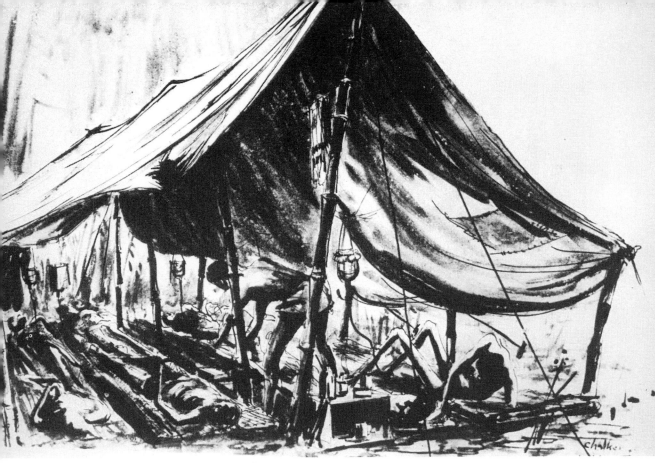

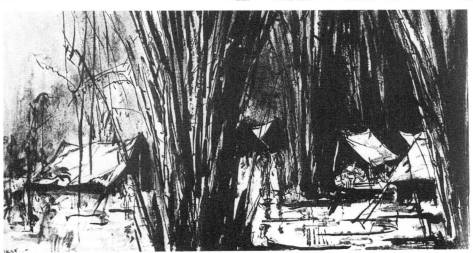

Cholera tents, Hintok: Patients lying in pools of water from the monsoon rains. Saline drips administered by means of bottles from which the base had been removed and rubber delivery tubes from stethoscopes. Saline was made by means of primitive stills from scrounged pipes and tin cans.

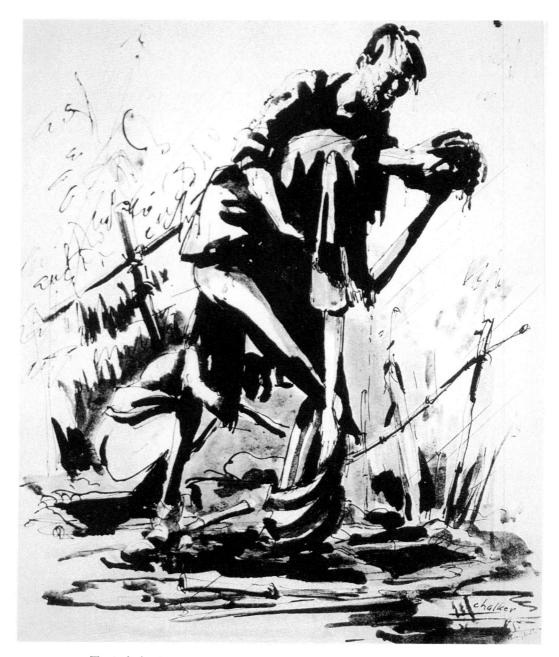

Typical latrines in up-country camps: Showing the small later adjustments to the aperture of bamboo to prevent debilitated prisoners from collapsing into the pits and drowning. During the monsoon season these areas were a sea of mud and maggots through which we waded barefoot.

that my good friend Jack Donovan became desperately ill with dysentery and too ill to move. He lay in his own faeces covered in flies, but with the help of torrential rain and handfuls of mango leaves we managed to clean him up and leave him a little refreshed. He survived, but developed a particularly bad tropical ulcer and some months later had his leg amputated. Thankfully his great heart and good humour brought him through.

Tools on the work sites were primitive: chunkuls, picks, straight-handled axes that were jarring to work with, spades, and two-handled baskets for carrying earth and stones. Long, coarse two-handled saws were used for felling the teak, kapok and other trees. Mechanical equipment was unknown up-country, although a sawmill was rigged further down for the long Wampo viaduct. Railway sleepers were made of hardwoods and the 688 bridges were constructed of timber felled and cut to size on site. Thai elephants and their oozies were used along the entire track to drag timber for bridge-building and it was a pleasant change to assist in washing the elephants in the river after each day's work. Ballast for the track was provided from rock broken by hand on site and where possible gravel had to be carried up to the railway site from the river bed. Rails were spiked direct into the sleepers, four spikes to each, and spur lines were planned at 10-mile intervals where possible. Much of the ground to be dug was hard and contained rock often requiring hammer-and-tap and picks to break it up. The work on the cuttings through steep hillsides was particularly heart-breaking and indescribably difficult.

In the jungle the clumps of bamboo *spinosa* were 20 feet or more across and as much as 70 feet high. Although feathery and beautiful to look at, its branches had huge, iron-hard spikes up to 4 inches long which tore into hands and legs, often inflicting painful and dangerous wounds. Clearing these clumps was difficult and extremely exhausting, and in our debilitated state scratches from the bamboo all too often turned septic and developed rapidly into rotting tropical ulcers.

The cuttings were completed almost entirely by hammer-and-tap, with the addition of blasting charges where the Japanese engineers

thought it necessary. Even the sinking of a hole for the charge by hammer-and-tap could take hours of jarring, back-breaking work. The guards took few safety precautions when blasting and on occasion prisoners were severely injured by flying rock as charges were detonated without warning. Some of the more sadistic guards were entertained by this.

Perhaps the most infamous such area was Hintok, where the Australians were subjected to appalling injuries by murderous guards with much loss of life. I visited Hintok Camp during this period on a line maintenance expedition and was horrified: bad as conditions were in Kanyu, Hintok was immeasurably worse; the Kanyu–Hintok section of the railway eventually provided the highest number of casualties on the whole line.

The Australians at Hintok had to construct long, deep cuttings through hard limestone together with a vast stone embankment on a precipitous hillside and a long, tiered viaduct some 80 feet high curving around the hill. This last was known as the 'Pack of Cards Bridge' after it had fallen down three times under the weight of rolling stock.

The Australian camp was near the river and a good mile from the working site, which was approached up a steep gradient – in one part by means of crude bamboo ladders – making the daily journey a daunting undertaking even before the work itself began. It was at this camp that I first heard of the legendary 'Weary' Dunlop, an Australian surgeon serving as a colonel in the Australian Army Medical Corps. He had already made history in Java with his surgical prowess and courageous defence of his men, and these qualities were also evident at Hintok, bringing great comfort and strength to those in his care.

In mid-March, 1943, many of our guards and most of the Japanese engineers moved to the two Kanyu top camps, leaving a much reduced complement to supervise the river camp. Groups of prisoners were selected to move to these new camps and I was fortunate not to be among them. Men from the Kanyu Cutting were being carried back down to Kanyu River Camp 'hospital' in terrible shape. They had been forging a cutting through the western face of a steep hillside

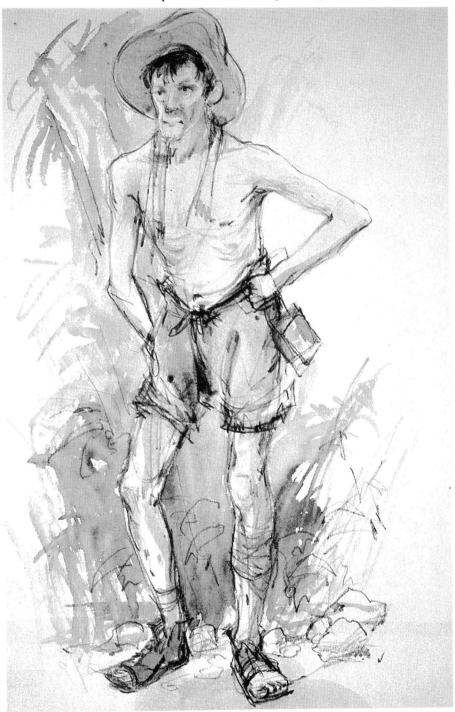

Australian prisoner, 1943: One of the workers on the infamous Hintok section of the railway trace.

working in day and night shifts – the latter by the light of fires on the edge of the work areas. The place earned the title of 'Hell Fire Pass', for it looked, and was, like a living image of hell itself.

Apart from the few humane guards, the work proceeded under savage pressure from the rest with constant beatings and heavy physical reprisals for any real or imagined lack of effort. Sickness was regarded as a crime, disabling ulcers were deliberately struck or kicked, and men who collapsed were often beaten mercilessly on the ground. A frequent punishment on the railway working site was to make an exhausted prisoner hold a heavy stone above his head and then beat him when it was dropped. Sufferers from dysentery were compelled to foul themselves whilst working and on occasions there were deaths on the working site as a result of deliberate Japanese bestiality. Those too ill to be dragged out to work were denied their paltry pay and their meagre food ration was also reduced.

The 'speedo' phase set quotas of working men to be filled daily, even though this meant sending seriously sick prisoners to the work site against courageous pleading by our harassed MO and the small band of officers who had chosen to remain with us in Kanyu. As the Japanese became increasingly anxious to complete the task, the pressures were even more ruthlessly applied, producing an ever-increasing number of sick and dying men. The Commandant merely commented that those who died would raise the working percentage.

Up-country in the working camps there could be no replacement of clothes and the Japanese made an issue to prisoners of G-strings which a wag had named 'Jap-happies'. These were pieces of thin cotton about 8 inches wide and a yard long, with a tape sewn cross-wise at one end. The tape was tied about the waist with the cloth hanging down at the back, then the cloth was pulled forward up between the legs and passed behind the tape in front and the surplus allowed to hang over in front of that. Some were white and some black: the latter we referred to as our 'evening dress'. By means of barter I acquired the remains of an ancient blue woollen jersey. It was full of holes and alive with lice, but it was a prize possession. I spent

some time sewing up the disintegrating parts with a home-made brass needle and bits of wool extracted from the garment itself. It was a great comfort during the colder nights and I kept it until we were released.

The daily routine began at dawn. We ate a ration of rice with any additions the cooks could manage, perhaps a soup-like concoction, and some weak tea. After a second issue of rice to be carried with us for a midday meal, tools were drawn and men counted and the groups would struggle up the precipitous path to the work site. A break was allowed at midday. Depending on the amount of work done, the mood of the guards and the number of helpless sick in the party, work could end in daylight or darkness. The exhausted few still standing would slip and slide back down the track to the camp for a further issue of rice and whatever else was available, before collapsing on the bamboo racking to sleep.

In the early days at Kanyu, ration parties were assembled to collect vegetables and sacks of rice that were brought to the hill-top by bullock carts on jungle tracks. It was an arduous task carrying the stuff down in huge open-weave baskets slung on bamboo poles between two men. The track down was extremely steep, worn smooth when dry, part-waterfall in wet weather. As all 'fit' men had to work on the railway site it was the 'standing sick' – that is, anyone who could stand up – who had to perform these fatigues. Not only did it take a great deal of time but more often than not some of the carriers had to be carried back. Later most of the food was brought up in Thai river boats – long, elegant teak structures with an eye painted on each side of the bows to keep away evil spirits. Occasionally from these we could barter or buy something to supplement our diet. Some of the boatmen and their families lived on board and cooked on small charcoal fires at the stern of their boats. Sometimes they might offer a handful of rice or a banana to those unloading stores and there was competition to get onto an unloading party.

Working men were paid by the Japanese in Thai *tical*, and although this only amounted to about a farthing a day it provided at least

something with which to buy a duck egg or some fruit. Subsequently a hospital fund was organized to purchase eggs and other available food for the sick and this became common practice in many camps. This little extra food could literally mean the difference between life and death. Eventually the Japanese allowed Thai traders to set up a small hut in Kanyu where, if we had any money, we could buy duck eggs, bananas, tapioca biscuits, sweet potatoes and pomeloes, as well as an ersatz coffee made of ground-up burnt rice. This last we also made ourselves. Sometimes the guards would throw a blasting charge into the river to stun fish and a few prisoners would be allowed to bring out the harvest, a very small proportion of which might be given to the camp for the very ill. The arrival of a buffalo or a pig in the camp was always heartening, but this was a rare event and when cooked and shared between hundreds of prisoners it became little more than a meaty smell in hot water. The starvation diet made our systems react violently to any richer foods and an infusion of pork produced instantaneous diarrhoea. This on top of almost continuous dysentery – if that seems possible – took away much of the fun of having a little extra nourishment.

Our huts overflowed with heavy sick suffering from a range of tropical diseases and the ever-present diphtheria. Wounds and severe tropical ulcers had to be covered with rags and old pieces of rotting mosquito-netting. Antiseptics were non-existent and at Kanyu during the early days the MO had only one small bottle of mercurochrome and a few quinine tablets. A POW from my regiment with extensive weeping sores over his whole body had tied on filthy bits of rag to defend himself from the maddening attention of the flies. About 6 stone in weight, he looked like a resurrected Egyptian mummy and earned the nickname of 'Lazarus'. Tropical ulcers were more often than not quickly filled with maggots, causing further extreme agony. These patients were surrounded with flies and the stench from their rotting flesh pervaded the whole camp. Rag dressings had to be removed, scraped free of pus, boiled up in an old tin and replaced on the patient.

Bamboo spinosa: The hard thorns were responsible for causing appalling wounds during jungle clearance.

But it was not all misery. In the dysentery hut skeletal inmates instituted daily sweepstakes on individual scores reached in motions per day and the man who reached the highest score without cheating won a cigarette from the pool. Some of the winning scores, which were strictly accounted, reached sixty or seventy for a twenty-four hour period. Dysentery patients also ran a lottery on who would be sitting on the only bucket in the hut when it finally collapsed. Such things provided a great deal of laughter.

From time to time it was possible to purchase some very rough tobacco – vile stuff, coarse and strong, but the avid smokers craved it. Paper for cigarettes was scrounged or stolen and we had to guard any books against tobacco thieves. The Bible made the best papers and was most sought after. Cigarette-making became a lucrative business in the sick camps later on, but in Kanyu it was in its infancy.

During this period there were some extreme examples of cruelty by the Japanese and Korean guards. On one occasion a group of the latter made a small bamboo cage in which they placed a tree-rat, a rather lovely squirrel-like animal with a banded tail. They then sat in a circle about the cage, poured petrol over the animal and set it alight, laughing and clapping at its torment until it died. Such behaviour to animals was not infrequent.

Among the Japanese guards there were however some with a more civilized attitude. One of these, Kanimoto, a former bank clerk from Tokyo and older than many of his associates, is remembered with affection. He had a quiet, stocky friend, Kanimit-san, who was a ju-jitsu expert and a man of similarly humane attitudes. These men never beat us and they apologized for the behaviour of their fellow guards, going out of their way to shield us from trouble and giving us as much rest as possible on working parties. They might well have suffered had their more considerate attitudes been observed by the Commandant. Kanimoto slipped us odd bits of food when he could and during one of my bouts of fever went on a foray down-river and brought me back a tin of condensed milk, which was enjoyed enormously by those of us who shared it. Kanimoto liked to come

into our hut to discuss life in England. He had a particular interest in art and music, and despite the language difficulty we managed to exchange information on these subjects with the help of a pencil and scraps of paper. Kanimoto knew I was an artist and on Japanese Army postcards which he readily supplied I made a few watercolours for him of Thai jungle landscapes and people. He gave me a small Chinese notepad of cheap, yellowish, coarse paper, not unlike soft lavatory paper, and many of the early notes I made at Kanyu and beyond were on the leaves of this modest present. From him I also obtained an additional supply of Japanese stick ink.

While Kanimoto and his friend sanctioned certain drawings and notes of the camp and its surroundings, they warned me very seriously that this would not be tolerated by other guards or the Commandant and that any visual records of the conditions and tragedies of our daily working life would, if discovered, incur severe punishment. I took this to heart and made a false bottom to my haversack in which to hide both drawings and materials. I also made a wooden stopper for a small section of bamboo in which I could conceal drawings, burying it in the ground under my bed space. Unhappily, during one of my sessions in the dysentery hut I was hiding some drawings in this section of bamboo when a Korean sentry suddenly appeared and immediately focused his attention on my papers. He looked carefully at each in silence and then began the expected shouting and hitting and made me tear the drawings into very small pieces. This was only a prelude to the real beating, and the next two days were a nightmare. When at last it was all over and I was back at my bed space I found two small drawings that had escaped detection under some rags. One of these, a drawing of 'two working men', seemed to sum up our existence more than many of my notes and it has a special place for me among all the prison drawings.

Despite the hazards of the march up-country a surprising number of books arrived in camp and they were passed around with great care, providing a means of temporary escape. I had a paperback copy of Kenneth Grahame's *Wind in the Willows* and a small pocket edition of

some of Rupert Brooke's poems which had been with me since we left England. These gave me constant delight until some vile character stole the *Willows* for cigarette paper about a month before our release.

Recovering from attacks of dysentery, malaria and other fevers gave me a chance to make additional drawings and notes of camps and our surroundings and also to watch and observe the jungle and its intriguing inhabitants. I remember after a severe dose of dengue fever in late November crawling down to the river's edge with another patient and lying in some reeds on a sandbank in the hot afternoon sun watching the brilliant blue kingfishers diving for food in the river. We were well away from any guards and we lay, strangely contented, listening to the bubbling of the water through the reeds about us and to the gibbons in the jungle across the river. My fellow prisoner was unable to speak and was frothing at the mouth, but he too seemed thankful for that break away from the sick huts full of stench and flies. Sadly, my companion died of diphtheria the next day.

During the dry season the river level dropped considerably and we discovered a hot spring bubbling through the sand half a mile downstream. Here we had our first hot wash for a year. It was most welcome and refreshing, but the great heat was so exhausting that we were faint with the shock of it.

As we cleared the jungle for the railway we daily discovered new and interesting phenomena. From the trees hung huge red ant nests formed by leaves that had been pulled together and containing layers of cellular structures full of eggs, pupae and a multitude of energetic workers. Elsewhere graceful weaverbird nests, intricately woven from dry grasses and shaped like tall Chianti bottles with small hanging handles at the base for landing on, hung from low trees in small colonies. We hated having to fell their supporting trees. Soon after our arrival in Kanyu we heard sounds above us in the jungle one night as if giants were running amok. A large herd of wild elephants was moving rapidly through the jungle like an army of tanks, snapping bamboo and small trees as they went. With an occasional high-pitched trumpet call they passed close to our hut and we could just make out

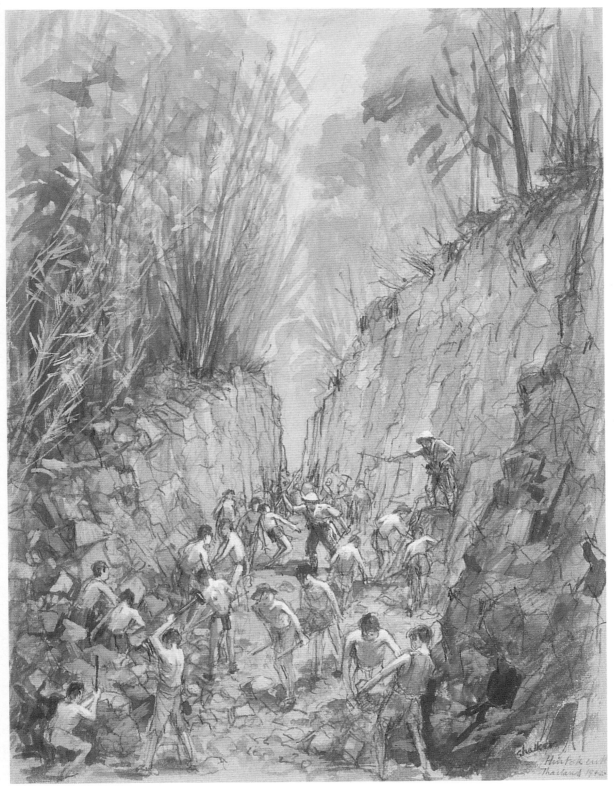

Hintok Cutting, 1942 — 1943: Australian prisoners working on the infamous Hintok cutting removing hard limestone by means of 'hammer and tap', and by blasting. This was unremitting hard labour under appalling pressure and great bestiality from the guards, resulting in much loss of life and injury.

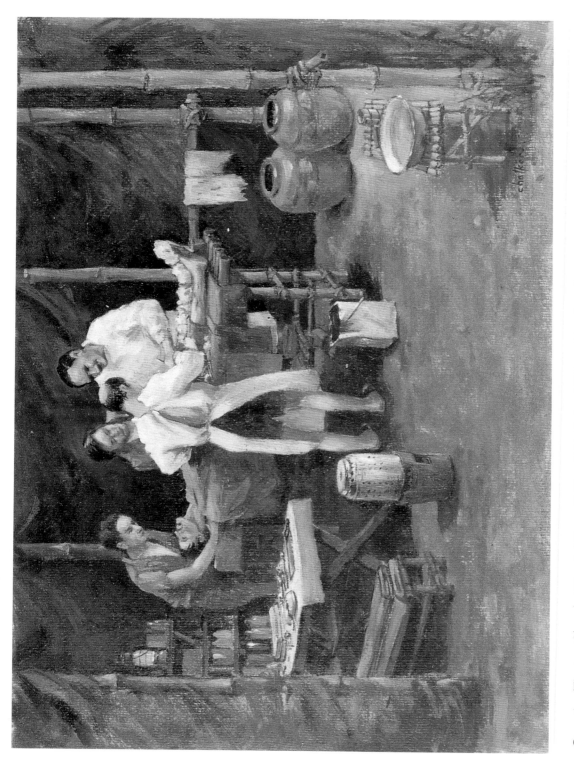

Operating Theatre, Chungkai Hospital Camp 1943 – 1944: Colonel 'Weary' Dunlop (facing) and Captain J. 'Marko' Markowitz (back view) working on a thigh amputation case. The Theatre was a small area of about twelve square feet within a bamboo and attap hut lined with old green mosquito netting. Earlier leg amputations had taken place on bed-space bamboo racking at the end of one of the surgical huts.

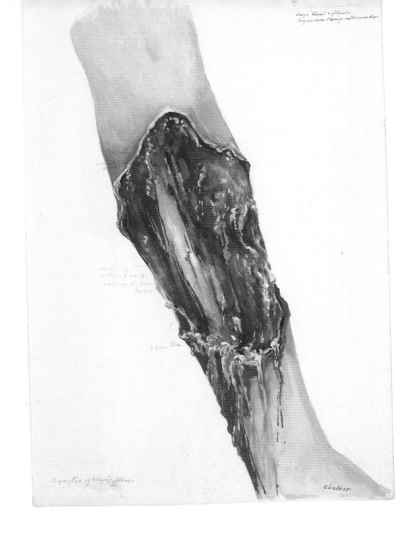

Tropical ulcers, 1942 – 1943:
Examples from a range of my
medical notes made in Chungkai.
Typical of hundreds of ulcer
patients coming down-river from
the railway working camps.

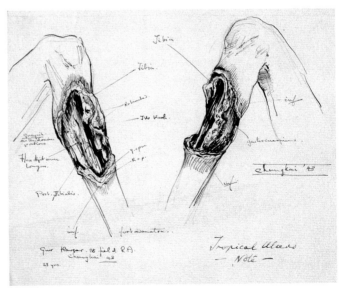

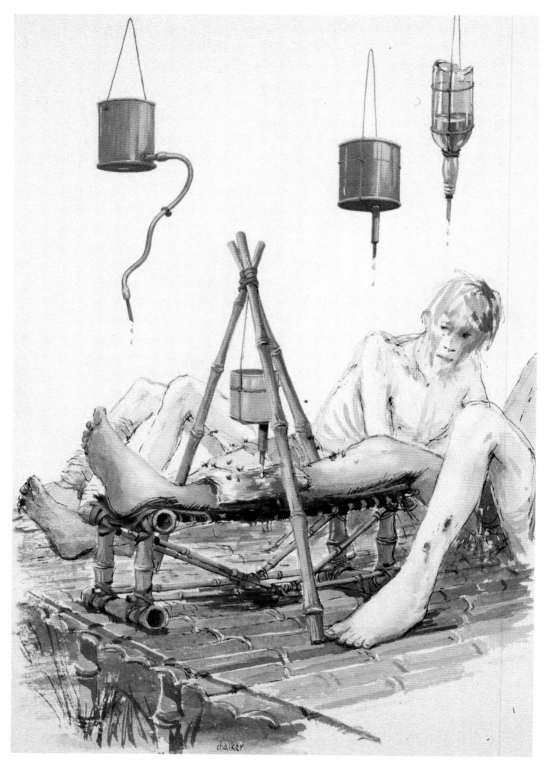

Chungkai, 1943: Pen and wash drawing to show the use of bamboo leg support and improvised saline drip apparatus for irrigation of ulcers. Old cans were adapted by other patients to serve this purpose and delivery tubes had to be made from stethoscopes. Dressings were of old pieces of mosquito netting and rags that could be scrounged from the kits of patients who had died. Used dressings were then scraped off, boiled in tin containers, and reused.

Surgical retractor and anaesthesia mask, 1943: The retractor was made from the lid of a Dutch army mess tin and used from 1943 onwards for leg amputations. The mask was made from an old gas mask with a condensed milk tin covered in gauze at the base. No surgical saw was available for amputations and an old tenon saw was employed throughout for the purpose, along with a range of sharpened-up butcher's knives, wire and a range of other ingenious instruments manufactured by craftsmen in the camps.

the huge dark shapes and white tusks as they thundered down to the river.

Later, on a survey expedition down-river with two Jap engineers, we were cutting a path through 6-foot elephant grass growing in a curious oasis in the midst of dense jungle. During one the *mishi* breaks I wandered back to the edge of the jungle and was watching some birds high in the trees when I became aware of movement in the scrub to my left. To my great surprise and delight a small brown honey bear appeared. It stood upright on its hind feet in front of me, only a yard or so away, looking at me and wrinkling its nose. We regarded each other quietly for a full half-minute, then it went down on all fours and loped off into the vegetation on the other side of the path. There was more to come. As I walked farther into the dense jungle I heard a distant thudding and about 50 yards ahead a herd of wild pig came thundering across the track and into the bush on the other side. There must have been more than a hundred of these long, black-grey creatures with pendulous bellies and very long snouts. I must have been conveniently downwind as they seemed quite unaware of my presence.

Such occasions were a great privilege, but there were also less welcome jungle inhabitants. Dull red, armour-plated centipedes up to 9 inches long were armed with an agonizing sting that rapidly produced fever and inflammation. We made sure that our boots were empty before putting them on – that is, when we had any boots. Large black scorpions could draw blood with their heavy pincers and they had a terrible sting. One night during the tail-end of the monsoon I was stung on the throat which caused agonizing pain and immediate swelling to the point where I could barely swallow. Some months later, as I crept into my rice sacks one night, I felt something run across my thigh and I grabbed at it. It was a scorpion and it slammed its pincers into my hand and stung me with malevolent intent on the end of my most private part. Within a few minutes it had swollen to the size of a grapefruit and I was rolling about in agony, unable to relieve the pain. The other occupants of the hut, all of whom were

heavy sick, were hysterical with laughter. A medical orderly covered in sores fetched the MO, who on seeing me was also unable to contain his laughter. As we were without medical supplies of any sort he could only say, 'Perhaps you had better put it into hot water!' This brought the house down. It took days of excruciating pain before I regained my normal function, but the joke went on for years.

Relations with our own officers in the camps were mixed. In November, 1942, a large body of British officers, including some of high rank, arrived by barge at Kanyu, bringing a vast amount of personal kit. They segregated themselves carefully in a camp nearby, apprehensive of our diseased and unhappy condition. They had no idea of our problems, nor any desire to comprehend them. In our camp there were six or seven officers, two of whom were from my own regiment, and all of whom had been with us since Singapore. On the arrival of the newcomers they were ordered summarily to move into the officers' camp. Our officers refused and I understand that they were then threatened with courts-martial and other ludicrous punishments. Later, much to our delight, our Japanese Commandant ordered a party of officers from the neighbouring camp to work on the railway. The squabbling and use of rank to avoid working were particularly nauseating and drew appropriate comments from our guards. We honoured those few gallant men who continued to stand by us. They took it in turns to come up each day to the railway site and to defend us against the daily beatings. Sadly, most of them died within the next six months.

In early November a party of sailors arrived in the camp, survivors from the cruisers *Renown* and *Repulse* which had been sunk on the east coast of Malaya at the time of the invasion. From them we obtained more up-to-date scraps of world news. One of their number had been badly shell-shocked and was given to bouts of screaming and rushing about the camp.

The monsoon had not quite finished and subjected us to days of particularly evil storms and torrential rain, turning the camp and the railway site into a quagmire, tearing the attap roofing off our huts and

Nigel Wright, Chungkai and Nakorn Pathon, 1943 – 1944: A geneticist and close friend.

increasing everyone's misery. On 16 November the Japanese shot a cheetah that had been raiding chickens in the Japanese compound. It had been visiting the camp for some weeks and we frequently glimpsed it at night as it ran between our huts. One of our number had to dress and stretch the pelt for the Commandant. About this time an evening concert of sorts was organized by 'Fizzer' Pearson, an officer from an adjacent camp, and this became an event to look forward to whenever the Japanese allowed a *yasumi* day. These concerts took place around huge fires on the edge of the jungle.

As we moved into December preparations were made for our first Christmas in captivity. On Christmas Eve we built a large fire on the slope above the camp and sang carols, watched by some of the guards. A *yasumi* was granted for Christmas Day and we had a celebration breakfast of 'browned' rice with a little sugar, followed by a pork 'rissole' made of rice with a porkish flavour, and 'lime' pudding, a small shape of pounded rice with a little lime juice squeezed into it. It was a feast to us and the prospect of a day to ourselves was something to look forward to. A service was held in the morning and the evening was spent around the fire singing carols and songs, with entertainment by 'Fizzer' Pearson and other comedians. It was a strange and moving scene as sick men lay out in the open near the fire, carried there by friends, with figures stretching back into the semi-darkness against a backdrop of tall, dark jungle. We sat and talked into the night under a waning moon and wondered how many more Christmases we might have to celebrate in captivity, if we had the luck to survive. For some it was already their last and more crosses had to be set up the next day.

Work resumed the following morning and for the first time we saw lorries arrive on the track by the railway working site. They had brought stores for the Japanese, which included tubs of salted plums. New Year's Eve came on a Thursday and once again we were allowed to celebrate round a fire above the camp near the edge of the forest. It was another unforgettable occasion, full of earnest good wishes and raised hopes. The Japanese had a celebration of their own with large

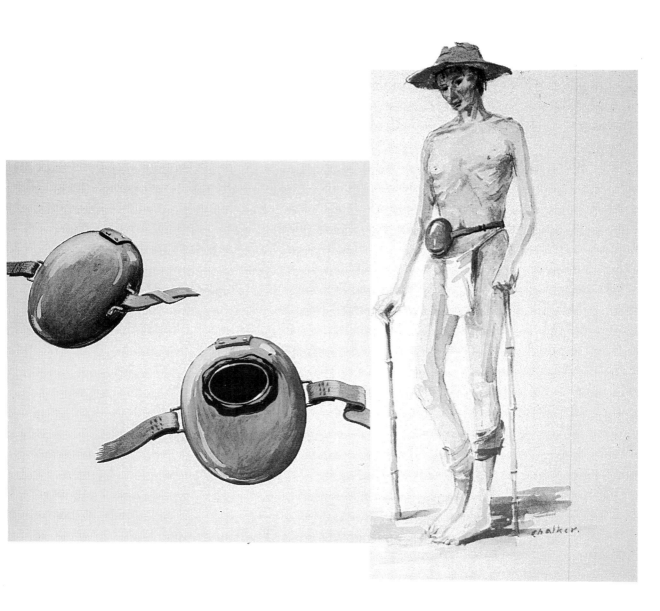

*Ileostomy and colostomy bottles, Chungkai and Nakorn Pathon, 1943 –
1945:* Made from Dutch army water bottles with the aperture faced
with pieces of old motor tyre and held in position on the patient
with army webbing. The water-bottle spouts have been removed
and the hole sealed up. These proved very successful and were used
until the Japanese surrender.

70

quantities of beer and saki; they became very noisy and two guards had a knife fight.

Thus began 1943. On 5 January a collection of Nipponese parcels arrived for the guards, containing paper toys, small dolls, miniature kites and other knick-knacks. The recipients were like excited children with a Christmas stocking. The presents were accompanied by letters from geishas and other ladies, and these were distributed arbitrarily in forward areas to keep up morale. From the excitement that morning it seemed that the letters had the desired effect.

Just after the New Year, Captain Hazel, one of the gallant officers from my own regiment who had been with us since leaving Singapore and had stayed with us in Kanyu, developed diphtheria and died on Sunday, 10 January. His great friend and fellow officer, Captain Crofts, was already down with dysentery and, much to our sorrow, died some weeks later. We had lost two real and courageous friends.

February 11 was a Japanese *yasumi* day and a special occasion of some sort for the Imperial Japanese Army. We never understood quite what it was all about, but were grateful for another break. A few of us lay about on the rocks by the river watching lizards and iguana, and the antics of the gibbons in the trees. Racket-tailed drongoes were mobbing a rook-like bird and their aerial acrobatics were enchanting. Tiny humming birds were sipping nectar and the weaver birds were busy tending and repairing their hanging nests. It was a relatively happy day.

In late February, for the first time we heard high above us Allied aircraft which disturbed the guards. It was a great boost to our morale.

Hospital Camp, Chungkai, March 1943: A watercolour note made shortly after my arrival.

Chungkai

IN EARLY MARCH I succumbed once again to dysentery combined with an attack of dengue fever, and towards the end of the month found myself in a party of sick to be sent down-river to the 57-Kilometre Camp at Chungkai where a large hospital camp was being formed. We assembled our few belongings and I dug up the section of bamboo containing my drawings. These I secreted in the false base and sides of my haversack and on 26 March we struggled up the hill and assembled outside the upper Kanyu camp. There were about 100 of us, British, Australian and Dutch. We spent the night there and early the following morning we left in open Japanese lorries. The sun came up and the metal of the lorries became unbearably hot as we bounced along rough jungle tracks for some 20 miles. The steel plates on which we lay were bolted together and throughout the journey the bolt-heads slammed into our thin bodies as we were thrown about.

Around midday we arrived at Tarsau, the 130-Kilometre Camp, having passed some of the more advanced preparations for track-laying in these far less difficult areas. We levered our bruised and roasted frames out of the lorries and, after the usual interminable counting, had a look at our new surroundings. It was a large camp and had grown from the small patch of cleared ground on which we had shivered in our muddy pools many months before. It also had an extensive graveyard. There was a well-organized Thai canteen where a friend, 'K. P.' Kirkpatrick, and I bought a little sugar and later boiled up some of our own home-made ersatz coffee in an old tin. We sat beside our small private fire feeling singularly free, as if on some remarkable holiday.

The next day, after a medical examination, I found I was on the re-confirmed list for evacuation to Chungkai Base Hospital Camp. We were served a meal of vegetables and meat stew which we ate slowly, savouring every mouthful, not believing our luck. In the evening we had a fried egg on a rice 'rissole', followed by a meat and vegetable

pasty and real tea. We were almost in tears with the sheer taste of it and the opportunity to eat in peace, free from harassment. Watching continuously for the guards had become habitual and we ate like monkeys with a firm hold on our mess-tins and with a wary eye for marauders. No doubt we looked like mangy animals, covered as we were with foul, ragged clothing and with filthy rags over suppurating wounds, but the sudden release from the upper camps was a great reviver.

Our rest in Tarsau lasted two days and on the third we set off, ten men to each lorry, on an even more uncomfortable ride than before along jungle tracks. After five hours we stopped at Tamarkan where we saw rails in position for the first time. The River Mae Klong had been bridged with a construction of rough-cut trees from the jungle nearby and trains were already in operation over it. About a hundred yards up-river we noticed large groups of prisoners building the founts for a more permanent bridge to carry steel spans brought from Java. The Japs were using human pile-drivers to sink these founts in the river bed; divided and sub-divided ropes were heaved upon by gangs of prisoners who were orchestrated by a Japanese engineer on a high platform. It was a scene not unlike something imagined from the building of the pyramids. Here, in a violent storm and pouring rain, we lay for almost five hours near the railway track in great pools of water at the bottom of a cutting awaiting a train to move us back up to Chungkai. It was midnight before we left. Eventually an engine hauling the all-too-familiar steel box-trucks arrived and we were lifted and levered hastily in and moved up to Chungkai. There we were shouted out by the guards and counted by the light of flares. As we staggered into the camp we noticed four men tied up outside the guardhouse. They had been caught trying to escape, and the following day we were paraded to watch them dig their own graves and then be shot into them. It was not an encouraging introduction to our new camp.

That first night we were bullied into some empty, broken-down huts at about 3 a.m. Although my paints and records were well

concealed I was relieved that there had not been a search. Bruised and aching, we collapsed and slept in our wet rags on saggy bamboo staging. Some of our group who had to lie on the muddy ground had no chance to begin to dry out and were in a poor state. Those with open ulcers must have been nearly out of their minds with pain, and the wet and cold did not help any of us with fevers. At first light I went outside and stood near a clump of delicate, feathery bamboo listening to the early morning sounds of the jungle birds. The night wind had dropped and the rain had ceased for a little. It was sparkling and fresh with promise of sunshine, not unlike an early English spring morning, and for a few minutes it was an oasis of delight. I am constantly reminded of that time when waking early in England and hearing the first birds begin their territorial singing.

Dawn also gave us the first real picture of our new 'hospital' accommodation and it was discouraging. The sweet-foul stench of latrines and rotting limbs was overpowering. The huts were all in a bad state with great patches of attap roofing blown away, leaving gaping holes through which rain poured in torrents. Much of the bamboo staging had collapsed and the rest was already sagging and not far from breaking up. Latrines were little better than up-country, but at first we didn't have to wade barefoot through a sea of maggots and faeces to reach them. Despite this discomfort, we were heartened to see that the camp was large, set in most beautiful surroundings beside the river, that the food was better than up-country, and that there was a well-organized canteen. We could hear the laughter of children from a nearby *kampong* and the river here was busy with Thai boats. We seemed less cut off from the outside world.

We were able to wash ourselves in the river and I thought with amusement of Tobias Smollett's *Humphry Clinker* and the descriptions of poxy, overstuffed English gentry immersing their pendulous carcases in the hot springs at Bath to ease their excesses. What a contrast with this scene of skeletal prisoners trying to keep alive, laughing and joking at each other's looks and incontinence. My memories of Chungkai are of great surrounding beauty mixed with the stench of illness and

death, and the remarkable humour and inventiveness of fellow pris-
oners. There was no noticeable difference in the behaviour of the
guards here, but at least we were free from the crippling railway work.
I spent the first few weeks in a dysentery hut and made a few pen-
and-wash drawings of our 'ward' and its occupants, and in particular
a patient beside me who was virtually a living skeleton. He was a
mathematician who had been a university lecturer in the subject.
When he had energy enough we talked a good deal and he unwrapped
what had been for me a very dull subject and made it sparkle. I became
absorbed in his persuasive enthusiasm. One afternoon, while enchant-
ing me with the fun of calculus, he suddenly stopped talking, gave
me an amused chuckle and died; it seemed a contented end. Although
we knew he wouldn't survive, his death was still a shock. Sadly, I lost
his name and address and have never been able to trace who he was.

As health improved, the more mobile prisoners had to undertake
camp duties, such as foraging for wood for the cookhouse fires,
carrying water from the river, digging latrines, repairing huts and
unloading barges. Occasionally small parties would be taken outside
camp boundaries to forage. The great nightmare, constantly with us,
was of being sent back up-country, from where there was slender
hope of return. As the numbers of sick increased so did the demand
for working replacements from men who were recovering. There
were constant reviews of patients by the Japanese: parties were
assembled from those considered fit to work and they were sent back
up to working camps.

The months of March and April in Thailand are intensely hot and
humid and I spent some memorable evenings at this time with a
Javanese Eurasian friend, a flautist, sitting on the river bank while he
played traditional Javanese music and quiet classical excerpts. Such
occasions, often under brilliant tropical moonlight, were enchanting.
Just before sundown each day white ibis would fly back up-river to
their night roosts, their shapes reflected in the glassy, swift-flowing
water, and a hornbill might call. Sometimes at night flights of huge
fruit bats would glide silently overhead, silhouetted against the velvet

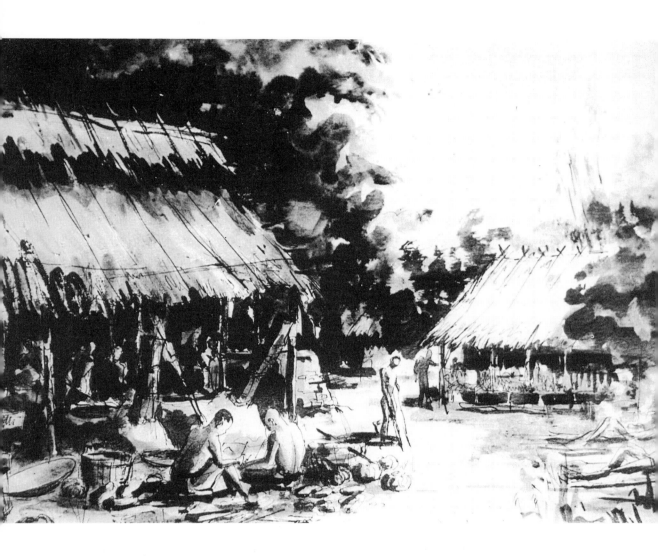

Hospital Camp, Chungkai, March 1943: Cookhouse is in the left foreground and the surgical hut is in the middle distance.

sky, and hang like black rags over a nearby mango tree. Gibbons gave an occasional whooping call or chattered intermittently as they settled for the night, and the large geckos would call from the bamboo supports of our huts. It was strange that these hauntingly beautiful moments could occur within a few yards of huts full of pitiful sights, stench, carnage and death.

Towards the end of May, 1943, we experienced some of the worst storms of our period in Thailand. The elements seemed determined to crush us, tearing down trees, damaging huts and producing extreme discomfort and difficulty. The river rose 8 feet in twenty-four hours, undermining latrines and spreading their contents across the camp. New latrines had to be dug as a matter of urgency and this was an appalling undertaking in pouring rain with the sides of even shallow pits disintegrating under the downpour. The dead still had to be buried and the shallow graves became small ponds. Great trees swirled down the river and it was dangerous to get more than knee-deep at the river's edge. Mostly we just stood in the rain to wash and the force of it stung our emaciated bodies. Here on one occasion I witnessed two lines of back-to-back, crouching sick men at a newly dug latrine suddenly leap from their bamboo footholds like desperate frogs as the sides of the long, deep pit collapsed and thundered below. I was glad I was a late-comer. Up-country in the early days exhausted and sick men had slipped in the mud and maggots and disappeared into the mess below, and the bamboo tops of the latrines had to be re-designed to prevent such tragedies.

Parties of desperately sick men arrived by day and night continuously throughout 1943, some by boat. I remember helping to unload one of the first of these river parties. Seven or eight barges containing dead, dying and desperately ill survivors had been poled down river for days without medical attention and scarcely any food; few were recognizable and I cannot remember one conscious occupant who was able to speak. Whilst we must have looked pretty rough when we arrived, it was nothing compared with these men. There were tears of horror and anger against the Japanese as we lifted the pitiful remains

Chungkai

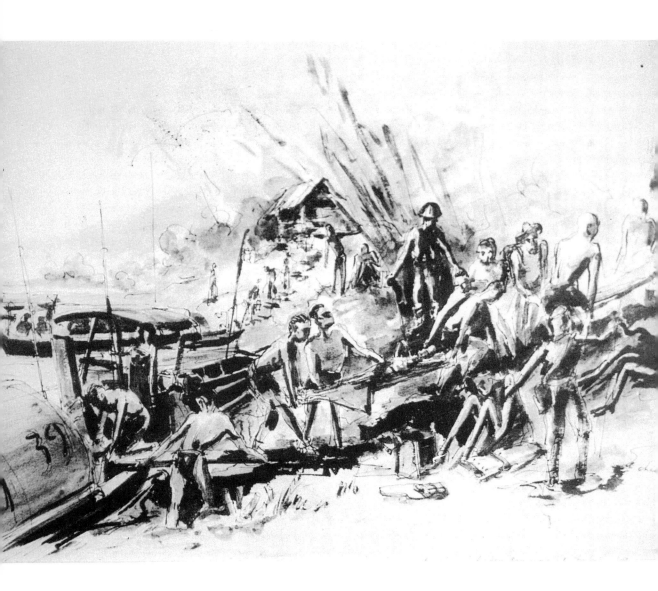

Unloading sick and dead from river boats, Chungkai 1943: Many of these desperately sick men had been in the boats for many days without food or help and many had died long before the boats arrived.

out of those stinking barges and carried them to the huts. On the river bank we threw water over the bodies of the dead to clean them up before carrying them to the mortuary shelter.

Sleep was a shallow, tense business. We could be turned out of our huts at any hour to be paraded for a roll-call, assembled for a working party or to be beaten up; even the desperately ill had to attend regardless of their condition. Such assemblies could last for hours and even a whole day or night if the Japanese suspected a breach of camp discipline. No one was allowed to leave the lines once on parade and on some such occasions sick patients died.

There were well over 2,000 heavy sick at Chungkai. In the early days it was a struggling, makeshift concentration with a small medical staff of British, Australian and Dutch doctors and orderlies, few medical supplies, little equipment and a constant flood of desperately sick patients. The situation required help of every sort from anyone capable of playing some part in corporate survival. As up-country, sick men helped those more ill than themselves and patients assisted the few trained and overworked medical orderlies, some taking on this role on a long-term basis while in the camp. Diphtheria and scrub-typhus cases were isolated as far as possible, as were those with extensive skin diseases and leprosy. Cholera had a separate area from the rest of the camp. Conditions for patients in the ulcer huts were pitiable in the extreme; the flies and the risk of cross-infection, as well as the stench of rotting limbs, were a nightmare.

It was in these early days at Chungkai that I had the privilege to meet and work with the legendary surgeon, Captain (Professor) J. Markowitz, a Romanian-born Canadian. He was a brilliant experimental surgeon and had been responsible for the first of the early successful organ transplants in animals in the mid-1930s. In April, 1943, with the rising number of ulcer cases, 'Marko', as he was called, performed the first leg amputations. The earliest of these took place on the bamboo racking, at the end of one of the surgical huts, but subsequently a more appropriate operating theatre was set up in a separate bamboo and attap hut, using an area of some 10 feet square

lined inside with bits of old green mosquito netting. Within nine months, and in addition to a variety of other surgical cases, Marko had removed more than 120 legs. Most leg amputations and some abdominal surgery were performed with Novocaine administered as a spinal anaesthetic, the patient being conscious throughout. Anaesthesia for dental problems was virtually non-existent. I worked with Marko in the theatre making surgical notes and records, some of which were for the development of new skin-flap shapes for mid-thigh amputations, tropical ulcers and avitaminosis patients. For those with ulcers, necrosed and gangrenous tissue, maggots and sequestra had to be removed by curettage and excision without anaesthesia; the early tools for this, in addition to any available surgical knife, were a dessertspoon and an old pair of Spencer-Wells forceps. The agony that must have been endured by these hundreds of patients is indescribable.

Malaria and dysentery were almost universal problems and the majority of patients suffered from a mixture of major medical problems on top of varying degrees of avitaminosis. With the meagre rice diet there was little that could be done to alleviate this. Rice polishings – dusty bitter fragments of husk – contained a small quantity of vitamins B_1 and B_2 and were obtainable in small quantities, but the stuff was dry and unpalatable and few patients could get it down. Tapioca root was boiled into a glutinous slop as a 'soft' diet, but this was of little nutritional value and needed an added flavour such as lime or *gula malacca* to make it acceptable. Duck eggs remained invaluable and it was fortunate that a supply from outside could be maintained throughout. Tomatoes and vegetables were grown on occasion by prisoners whenever the Japanese allowed it, but this was mostly a small-scale individual enterprise.

Occasionally, when time could be found to do so, we tried fishing with home-made hooks, without great success. We had to be careful when swimming, for shoals of small fish would bite at any sores on our bodies. One fish became a camp legend: a sick man with a very raw tinea scrotum was washing in the river when a large fish removed

half of his scrotum in one bite. After surgical repair his main concern was that his wife might think he had been misbehaving and lost it through disease, so he demanded a signed chit of explanation from his MO, a slip of paper which he guarded with his life! Snake was always good to eat, though less available in the hospital camps than in the thick jungle up-country. Python were the best and offered good-sized cutlets; king cobras grew up to 18 feet and, although the girth was small, they were good eating. Large iguana moved quickly and were very difficult to catch; their white meat was a delicacy and much sought after by the Chinese. Wild cat and Pi dogs were eaten in desperation, as were rat legs, but down-country at Ban Pong there had been some suspicion of bubonic plague and we refrained from eating them when at Chungkai.

In June, 1943, cholera broke out up-country and soon appeared among us, and in my own hut, at Chungkai. Cholera was the most feared of all our tropical enemies. It has a violent and rapid onset, followed by rapid dehydration and death within a few days. In an attempt to prevent the spread of this virulent disease bodies were either burnt or, as we did in Chungkai, buried in deep pits well away from the camp. Nursing cholera patients demanded great dedication and courage on the part of doctors and medical orderlies, and throughout these epidemics emergency regulations had to be very strictly adhered to. Drinking water had to be boiled throughout the camp and was savagely rationed. Eating utensils had to be sterilized by dipping in boiling water and disinfectant. The Japanese were terrified of cholera and quickly produced disinfectants in the form of lysol and potassium permanganate. Whilst washing in the river every attempt had to be made to prevent the water getting near one's mouth. The annual cholera periods in the wet season were harassing times and we were always relieved when they were over. The 1943 epidemic lasted many weeks and took a heavy toll, particularly in the Asian workers' camps which were left totally isolated by the Japanese and without medical help of any sort. Some of the Asian camps were entirely wiped out by this disease each year.

Conditions in the sick huts in Chungkai were primitive, but with improvisation and ingenuity the camp worked remarkably well and the medical and surgical achievements were to become legendary. During the railway-building years there were few, if any, medical supplies from the Japanese, who appropriated all available for themselves; until a meagre ration of Red Cross supplies was made available in 1944, doctors had to make use of whatever materials came to hand or could be devised

The camp workshop began to produce a wide range of utensils and equipment for general and hospital use, and ingenuity and improvisation were crucial to our survival. A few of us with a knowledge of massage and physiotherapy formed a small unit to ease muscular and other problems and to help patients crippled with avitaminosis and amputees and ulcer patients with severe contractions. We had some success and small pieces of bamboo exercise equipment were devised and developed which were later used and refined in the larger hospital camp at Nakhon Pathom in 1944. We kept daily records of our physiotherapy patients in small Chinese notebooks sanctioned by the Japanese for the purpose, making particular note of our ulcer patients and amputees whose leg contractions we reduced by massage and exercise each day, measuring the maximum angle of stretch that a patient could progressively reach in response to treatment. I devised a pair of thin wooden calipers with a gauge for this purpose. For massage we used coconut oil as a lubricant which helped to prevent skin inflammation. Crude but effective stills were constructed from old tins and bits of stolen pipe to produce distilled water for a saline solution that could be administered intravenously to relieve the agonizing dehydration in cholera victims. An orthopaedic bed and an adjustable dental chair were constructed entirely of bamboo, and small pieces of equipment for physiotherapy began to be devised.

Amputees showed exceptional courage and fortitude. Loss of a limb was joked about and patients competed to see who could be first up on their bamboo crutches. Once mobile, they began to participate in all sorts of activities, including 'crutch races'; sweepstakes were arranged

over set periods with cigarettes as prizes. Some of the legless began to establish small businesses making and selling ersatz coffee and tea from dried hibiscus leaves. Most of the amputees learnt quickly to move about on their crutches and many worked with those in the camp workshop to produce remarkably efficient artificial limbs. The first of these was made of a stout bamboo shaft split in its upper third into three splayed sections to support a 'bucket' for the thigh stump. The bucket was made of canvas from old army packs with its upper edges padded with kapok gathered from trees in the jungle. It could be adjusted to fit the stump by means of two bullock-hide panels sewn to the canvas at the front and laced together with fine strips of bullock hide. The whole assembly was sewn together with thread pulled from army webbing. Later models were more sophisticated, made largely of wooden shafts, often with shaped calf and foot, and articulated at knee and ankle. There was great competition to obtain a 'new leg' and, despite the loss of a limb, the freedom from the months of agony with tropical ulcers seemed to give a new lease of life to these patients.

Our first commandant at Chungkai, 'Kokabu', whom we had met on our march up-country, embodied the paradoxical qualities of the Japanese character. Early one morning, as a member of a small physio team, I was summoned to his hut. After one of his drinking sessions in Kanchanaburi, Kokabu had some residual pain in his neck and shoulders and demanded a 'massagi-man' to reduce this. He roared his orders at me through an interpreter and attended by two armed guards I was forced to massage his neck and shoulders for about fifteen minutes, relieved that I didn't receive one of his usual beatings. He tried out the remaining four masseurs over the next few days and then ordered me to attend to his neck whenever required. These sessions became regular over the next six weeks, during which time the armed guards were dispensed with and only the interpreter

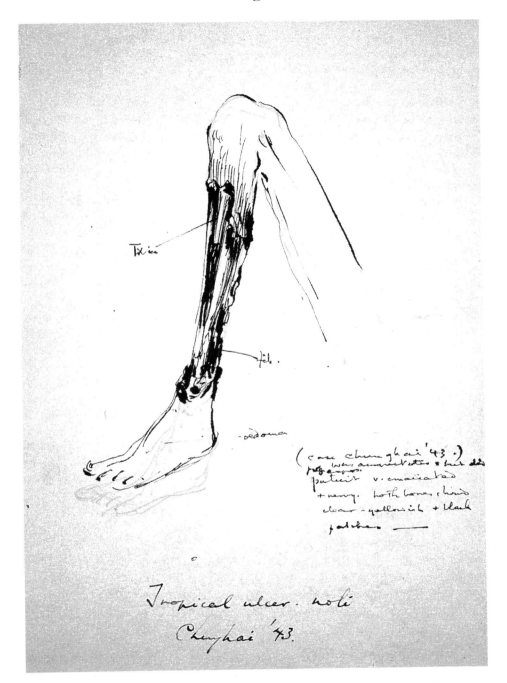

First leg to be amputated at Chungkai 1943: My notes made for Captain Markowitz 'Marko', the surgeon; this was the first of 120 legs to be amputated at this camp.

remained present. When the massage finished Kokabu would clap his hands and roar for food from his orderlies. I was ordered to sit on a floor mat on one side of his low table and have tea, rice and soup. Through the interpreter he began to ask searching and intelligent questions about English university life, our educational system, banking, ballet, painting – about which he seemed unexpectedly well informed – and a variety of other matters. He allowed me to question him about Japan, its university life, Shinto and Japanese painting. These interesting discussions with a man who had already achieved such notoriety for brutality and murder seemed hardly credible.

On one occasion I asked him why he held human life so cheap. His answer was simple: 'I am a soldier. To be a prisoner of war is unthinkable.' To him, an officer and a fringe Samurai, all was black and white; there were no other acceptable conditions. The Japanese refined love of beauty, manners, convention, gentle Shinto concepts and control are wildly at odds with their tendency to brutality both to others and to themselves. The masochistic and sadistic elements were only too evident, and it was easy to see how these could be channelled into fanaticism. Shortly after my sessions with Kokabu ended, he and his *gunso* returned early one night after going down-river to Kanchanaburi to seek their usual pleasures with some geishas. On entering the camp Kokabu found two of his duty guards missing: it was reported that they had gone to a kampong down-river to find some Thai women. Kokabu and his *gunso* hunted and brought back the missing guards late that night, and then over three hours systematically beat them to death. The noise of the shouting was appalling and there could be no doubt about the outcome.

Summary punishment could be exercised by a senior officer in the field for breaches of discipline or a culprit could be handed to the *Kempei-tai*.

Clothes were in short supply. They wore out and rotted and there were no replacements other than from those who had died. From old bits of blanket or cloth we cannibalized anything that could be transformed into shirts and shorts, although for most of us amateur

Captain Markowitz, 'Marko': The distinguished Canadian experimental surgeon who began a long series of leg amputations at Chungkai camp.

tailors sitting down in a new pair of home-made shorts was often a disaster. A number of Australians could knit, and the wool from remnants of old socks and jerseys was turned into such things as stump covers for amputees. During a sojourn in a fever hut I rediscovered the small skeins of Chinese silk that I had picked up in the burning house in Singapore. Surprisingly, my sick neighbour, an Australian farmer, said he had some experience of embroidery learnt from an aunt when a small boy in the outback. I had two small needles, and with his massive hands he showed me how to do some exquisite stitching. Neither of us was mobile, and this helped to pass the time. I spent some days producing a passable piece under his guidance and I still have it.

The unrelenting pressures of slave labour and illness in the railway camps produced cases of extreme depression and melancholia. On the other hand, there was much laughter and it was good to be with Cockneys and Australians who always had something on the go and with whom good humour was always present. Once, when I was in a fever hut after a bout of scrub typhus, there was an immense but emaciated Australian across the hut from me sleeping in the afternoon heat, barely covered amidships by a small piece of dirty rag which had been nudged aside by an erection. This was unheard of among us physical wrecks and news of this phenomenon spread immediately through the ward. A patient further along the hut had just finished eating a duck's egg and creeping up to the sleeping Australian he placed the large blue speckled shell on the end of this perky member. By now the men in the hut were bent over with uncontrollable laughter, with the exception of one Holy Joe, who struggled off his bed space and tried to remove the shell. This woke the Aussie, who, thinking that the man was interfering with his person, sat up outraged and gave him a colossal backhander, knocking him off the bamboo racking onto the mud floor. We were hysterical with laughter and the incident became one of the many hilarious railway legends.

A sadder tale concerned a Cockney gunner from my own troop, who was nicknamed 'Bugle' because of his large red nose. He developed

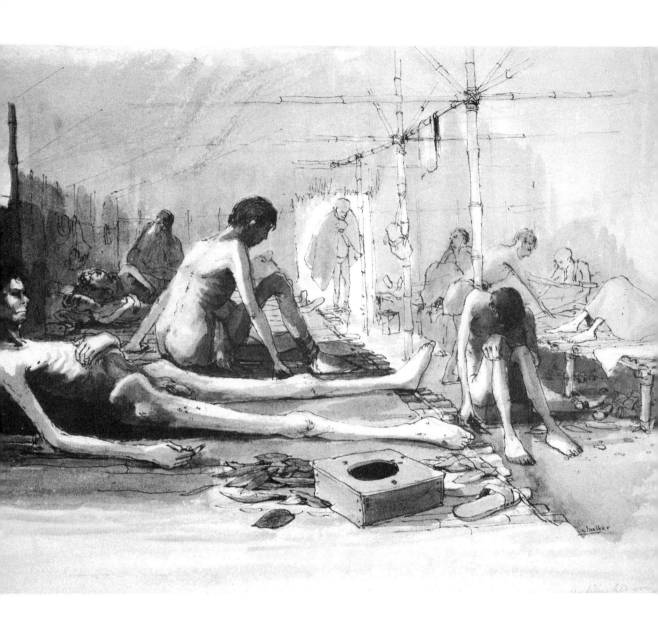

Dysentery hut, Chungkai 1943: This was the view as seen from
my bed space.

cerebral malaria, from which few ever recovered, and while delirious spent five days and nights hunting for buried treasure, calling out in his excitement and giving details of his diggings and expectations. Despite his desperate plight, his shouted commentary became a daily interest to all passing the hut. Sadly, he died before he found his treasure and we all hoped that he would find it elsewhere.

Another patient, Skillikorn, a tall, emaciated, benign character, began to live a Walter Mitty existence, sometimes riding an imaginary horse as a Wild West gunman, other times revving an imaginary motorcycle, all with appropriate noises and gestures. At first we thought he was pretending to be disturbed, but sadly it was very real. One morning he escaped, swam across the river and disappeared into the jungle on the other side. He was hunted down by the guards and made his return as a Wild West gunman, naked, wet and laughing, and shooting his imaginary '45 at the guards, who were both bewildered and disturbed. As a result of this the Commandant ordered a special enclosure to be built for patients suffering from mental breakdown. I met Skillikorn again the following year in Nakon Pathom Hospital.

There were a few suicides, but it was disturbing to observe how a sick patient could commit suicide without any evident physiological cause. Some of the Tamil workers on the railway, having convinced themselves that they were suffering from a medical problem far beyond any clinical evidence, were able to effect their own demise mentally, often within twenty-four hours. There was evidence of this also among a few European patients. One night while I was awaiting surgery for a badly splintered nose, a man across from me in the surgical hut, who was recovering from a leg ulcer, sat up and began rocking backwards and forwards on his bed space moaning continuously that he was going to die. Next to me on the racking was an Australian in bad shape who had had his leg amputated that afternoon. The Aussie, a cheerful, gutsy character, became fed up after an hour of this incessant bleating and raising himself up on his elbows called out, 'If you're goind to die, mate, bloody well hurry up and do it as I want some

sleep.' Within an hour the moaner was dead, much to the regret of the Aussie who felt that these were the last words spoken to him. A post-mortem the following day found no justifiable cause for death in a man who was physically in far better shape than anyone else in the hut.

On 17 October, 1943, the two ends of the railway met at Konquita, the 263-kilometre point north, and there was a formal opening ceremony on the 25th. The railway was at last through from Ban Pong to Thanbyuzayat, a distance of 250 miles linking Bangkok with Moulmein and Rangoon in Burma. It had been completed two months before the deadline. The news was spread to us by various guards, who expressed their pleasure with nods, grunts and many 'very-good-ta-na's' – but at what cost in human life and misery was this undertaking achieved. Parties of partly recovered men were still being sent back up-country for railway work and the stream of desperately sick coming into the camp remained unabated.

Later the same month, following Kokabu's example, a Japanese *socho*, nicknamed 'the Gorilla' because of his ape-like appearance, demanded a massage for his shoulders and back which he had strained during weight-lifting sessions with an emaciated British professional who worked in the Jap compound. Using improvised weights and clad only in a white Jap-happy, grunting and 'buggero-ing' with frustration at his incapabilities, he provided us with daily entertainment each evening after work. The thin, skilled prisoner took great pleasure in raising the weights which the Jap was unable to manage and the roaring during these sessions was a great source of amusement.

Despite his looks 'the Gorilla' wasn't a vicious guard and behaved relatively well to prisoners. I found that as soon as the massage commenced he would fall into a deep sleep. On my second visit I noticed under his bed a large jar of iodoform, an invaluable and almost unobtainable antiseptic, and on subsequent visits I took along a small box similar to a match box. Once he was asleep I eased the jar out from under his bed with my foot and whilst continuing the massage with one hand used the other to ease the top off the jar and extract

some of the precious crystals into the box. Over eight separate sessions I managed to escape with a small cache for use in the ulcer huts.

In the hospital camps we had more time to devote to a wider range of activities. Most trades and skills were represented and could be put to good use in camp workshops and for recreational activities. There were watch-makers, tinsmiths, geneticists, pharmacists, saddlers, tanners, snake-catchers, story-tellers, actors, wig-makers, tailors, artists, musicians, writers, instrument-makers and entrepreneurs of all kinds. With the increasing availability of coarse tobacco those who could split or manipulate papers to use for cigarettes could command their own price and earn a reasonable camp living. There were also the inevitable king rats who lived parasitically on everyone else.

Bamboo proved an extraordinarily useful and versatile material. Its sealed empty sections enabled it to float and many up-country Thai people built their houses on rafts of bamboo, living on the rivers through all seasons. In the jungle bamboo could be up to 6 inches in diameter and could be cut into sections and used as water pots and storage vessels. It could be notched and fitted together to fashion anything from furniture to houses. Its round section had great strength and long pieces could be cut lengthwise and, with the inside segments removed, be used to conduct water from streams on the hillsides. The shiny outer skin could be peeled off in long, thin strips and woven into matting or hats, and smaller sections could be cut and used as mugs, lamps, ladles, knives and forks, brooms and a host of other objects for daily use. As well as bamboo every available tin, pieces of wire and fabric, and bits of motor tyre, metal and nail that could be salvaged or stolen were prized and hoarded. Everything was valuable and nothing was wasted.

I had started to make a collection of drawings with 'Marko' and enlarged this considerably with 'Weary' Dunlop, both in Chungkai in 1944 and subsequently in Nakhon Pathom. These records we managed to keep hidden. While I could manage to keep the drawings from the guards, I was bedevilled by natural enemies. On more than one occasion, particularly up-country, I found that cockroaches had man-

aged to get into the bamboo section buried in the ground, where they had reproduced and eaten through the drawings which then appeared like small bits of pianola-roll and were completely ruined. I re-drew some, but many were lost for good. Later, termites joined the cockroaches and they could eat their way into the most carefully sealed containers. The attap roof was an alternative hiding place, but rats could dislodge objects secreted there and the Japanese had a habit of searching the roofing from time to time, so it was not very safe.

Towards the end of 1943 in Chungkai a new commandant, Saito san, demanded a 'sketchii-man' and I was ordered to report to him. He was a reasonable character and less formidable than Kokabu, but his orders had to be obeyed. He gave me a pack of Japanese Army postcards and ordered me to paint small watercolour vignettes on them of Thai people and landscapes. I made the point that I would need paints and brushes with which to do this and within a few days he presented me with a Japanese writing brush and a tiny box of almost unusable cheap Thai colours. At least I could cover myself with this small *presento* if they were found by the guards. I was ordered to produce twenty paintings a day under threat of being beaten up and incarcerated in the 'no-good-house' unless they were forthcoming, and this I did for a few wearisome weeks. It was an anxious marathon, largely undertaken at night by the light of a small wick in coconut oil in a bamboo lamp. Saito was supplying his fellow officers with them and they were being sent back to their families in Japan. For all this, I was awarded a small tin of stolen Red Cross cheese. I was relieved when it was over.

In Chungkai more study schools were formed with language lessons in French, German and Dutch, and lectures were given on a vast range of subjects, such as natural history, skiing, Greek mythology, cricket, chess, India, dance forms of Indonesia, physiology, anatomy, art, bakery, and so on. A Cockney cat-burglar friend in the camp, a sort of modern-day Robin Hood, gave some most entertaining accounts of his profession. He was a quiet, tiny man of immense courage and kindness and frequently risked his life going over the wire to contact

Thais and Chinese, selling and buying. On his return to camp after these dangerous escapades he would give much of his hard-won foodstuffs to sick and dying men.

Card schools flourished as ever and new packs were made from scrounged card with ink and paint waxed over with candle grease. Musicians devised and scribbled musical scores on odd bits of scrounged paper and began to assemble themselves into an orchestra. A Dutch Eurasian, the leading guitarist of Java, had managed to keep his guitar and from him we heard some beautiful music. An English prisoner had brought his violin and another his trumpet, both of which had survived the railway working camps. Other Eurasians from Indonesia seemed to have a particular capability to construct guitars from scrap material, using animal gut and stolen wire for strings, and from them we had some superb traditional Javanese music. Other members of the musical group produced a drum kit and a double base made from old tea-chests and bits of teak, complete with tuning keys. Within a short time an orchestra was formed and directed by Captain Norman Smith, a superb British musician. These talented and ingenious people gave great pleasure and hope to many with their music, which ranged from classical symphonies to popular music. A jazz quartet emerged from the main body and gave some magnificent performances that were great fun and a most welcome boost to morale.

Towards the end of 1943 the Japanese allowed us to build a theatre in Chungkai and to hold more formal concerts. In the camp, near the river, there was a natural shallow basin, which formed a large auditorium. A raised stage was made of earth with an orchestra pit in front and upon it was built a large bamboo and attap proscenium. Behind this were wings and dressing rooms over which was a bamboo and attap roof. Concert evenings, with the vast audience of emaciated men sitting or lying in that great dusty bowl of the amphitheatre, were a moving sight. The Commandant and many of the guards were in the habit of attending and a special area had to be reserved for them.

'Fizzer' Pearson had come down to the camp from Kanyu and his bubbling humour played a large part in the theatre productions. Gus

Chungkai

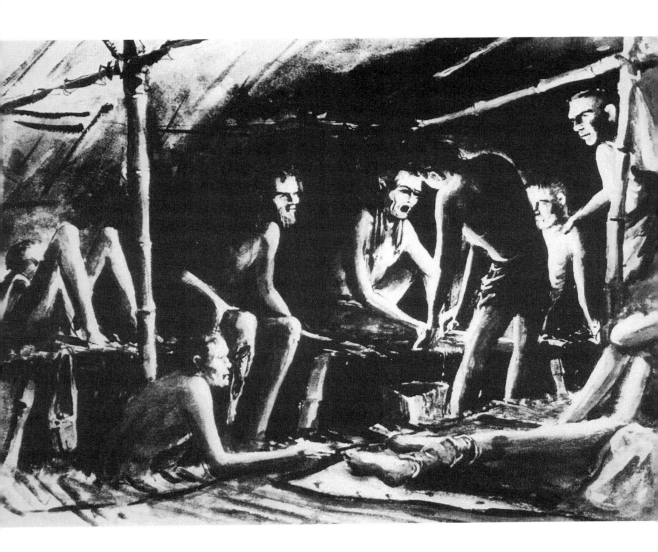

*Cleaning ulcers by night, Chungkai 1943 — 1944:*Clearing maggots and pus from tropical ulcers with an old dessert spoon and surgical forceps. Initial cleaning of these lesions had to be performed without anaesthesia.

Ancorn, a friend from my own regiment, had been the youngest member of the Magic Circle in London and was an outstanding conjuror. At Chungkai he was a most valuable asset not only in terms of providing superb entertainment but also in being able to divert the guards' attention whilst forbidden activities took place. He was in demand by the Japanese as a 'magic-man' and gave both them and us endless entertainment throughout the last two years. Burlesques, variety shows and plays were devised or written from memory and there was no shortage of theatrical talent. Permission for concerts to take place depended upon the whim of the Commandant, but on the whole the shows took place with reasonable regularity and played a vital part in our existence.

Our second Christmas in captivity was soon upon us, an official *yasumi* giving the opportunity to celebrate as we wished. Special efforts were made by the theatre group and the camp orchestra to provide a bumper show and a variety of music. This must have meant a great deal of work, rehearsal and preparation, and was an occasion to look forward to by everyone in the camp. Carols were sung on Christmas Eve and music was played by the orchestra in the sick huts for immobile patients. The cooks produced even more variations on a rice theme, with a small visible quantity of meat, *kachang idjou* and *gula malacca* and a rice 'Christmas pudding'. To this we added a few small luxuries from the canteen, such as a tapioca biscuit, banana or some peanuts. The camp orchestra and theatre group put on a wonderful show and we felt that we had had a day to remember with pleasure. Sadly, as before, the bugler continued to play the 'Last Post' the following day and more crosses were set up in the extensive graveyard.

We were allowed to celebrate New Year's Eve as we had done the year before up-country and it was memorable to some of us for an incident that occurred late that night after lights out. A Canadian prisoner had managed to get hold of some illegal saki smuggled into the camp and became very drunk. He announced his intention to pee on the guard hut to demonstrate his disdain – a highly dangerous

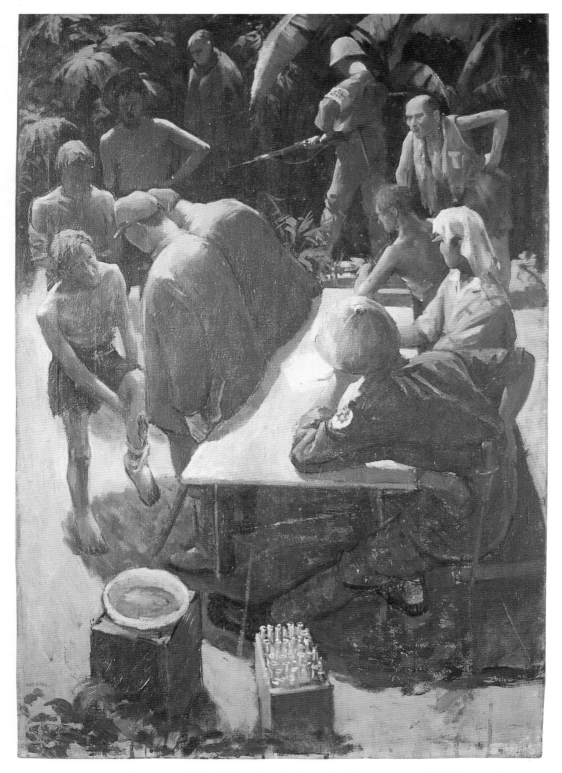

Chungkai Hospital Camp, 1943: This oil painting of a Japanese medical inspection was painted in London in 1946 whilst I was student at the Royal College of Art, from notes made in the camp. There were constant reviews of sick men by the Japanese guards in all working and hospital camps and working parties were assembled from those considered fit enough to stand to be sent back to railway work regardless of their condition.

Kanyu River Camp, Thailand, Jungle flowers, November 1942: Watercolour notes of passion flower, ground orchid, and hibiscus.

Theatre and auditorium, Chungkai Hospital Camp, 1943: View northwards past the 'sugarloaf' hill on the far side of the Kwai Noi River. The theatre was constructed of bamboo and attap. The auditorium, which could accommodate 2,000 people, faced the river and was fringed with palmyra palm, mango and papaya trees. It made an idyllic setting and some unforgettable productions took place there. Bamboo lamps with string wicks set in coconut oil provided lighting for orchestra pit and stage.

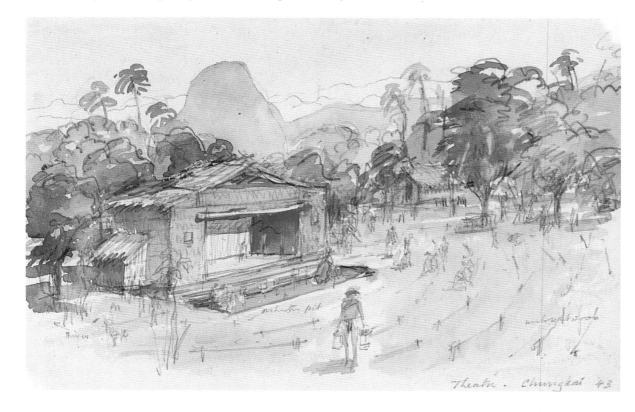

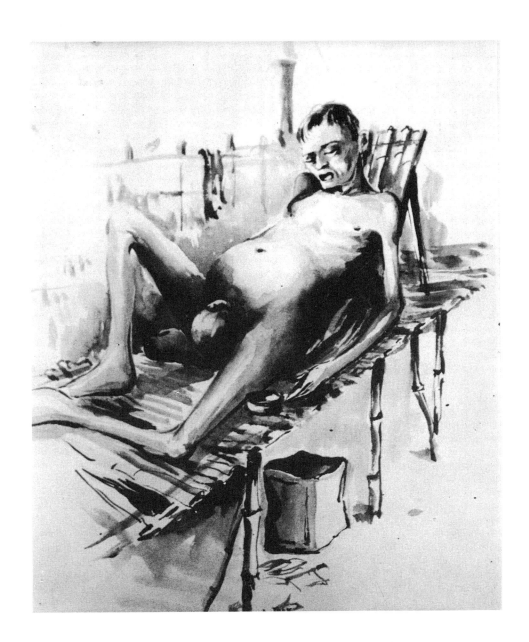

Hospital camp, Chungkai 1943: Starvation oedema patient.

gesture to say the least, quite apart from indicating that he had access to forbidden liquor. We attempted to restrain him, but he broke away from us and approaching the guard hut he made an exaggerated, theatrical bow to the sentry and proceeded to relieve himself on the side of the guardhouse. The sentry remonstrated, but instead of the expected beating there followed an animated discussion between the two, the sentry trying to indicate the latrine across the camp and the Canadian indicating that the guardhouse was really the right place, both pointing repeatedly in different directions. Throughout the conversation the Canadian continued to perform on the side of the hut whilst other guards came out to watch, offering alternative suggestions, and it was only when he had completed his copious business that the sentry gave him a few slaps and 'buggers' and sent him off. After giving the sentry another absurdly exaggerated bow, the victorious piddler returned to our hut laughing. Strangely, the guards seemed to enjoy the episode also and no doubt felt that it was a normal part of New Year celebrations. It was a foolish but amusing gesture and we were delighted that he had survived unscathed. For some of us at least 1944 started with laughter.

On 17 January, much to our delight, Colonel Weary Dunlop arrived in Chungkai to take over as Senior Medical Officer. His energy, surgical and organizational expertise, combined with his unfailing warmth and good humour, soon made themselves felt. Together with Marko, we had two exceptional men to look after us, and it was an immediate boost to morale. Within a short time desperately needed improvements began. Camp and hospital hygiene, hospital practice, diets, camp funding for the purchase of additional foodstuffs, equipment and medicines changed for the better.

It was in January also that I moved to another hut and once again had an Australian as a neighbour on our bamboo racking. On seeing me making some surgical notes he announced that he had some paints with him. To my astonishment he brought out from his haversack an

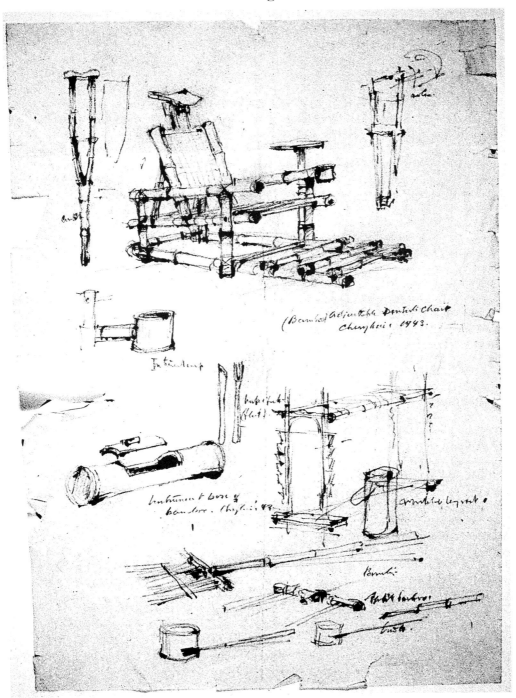

Bamboo in use for medical purposes: Some pencil notes of an adjustable dentist chair, crutch and leg prosthesis, etc.

unused Windsor and Newton paint box containing twelve tubes of artists' watercolours. This seemed unbelievable, doubly so as the Australian was not an artist and had no intention of using them. He had found this box in Singapore and for no apparent reason had carried it up-country to a railway camp and then down again, when sick, to Chungkai. I readily exchanged the paints for some ducks' eggs and the whole of my 'pay' for the month and became the owner of an unimaginable supply at the most opportune time. The problem was how to conceal it. I kept the tin box separate and empty, hiding the small tubes in the false side section of my haversack. All were turned over during the searches without comment and all survived including my original few tiny watercolour palettes.

In early March a small quantity of mail arrived, most of it eighteen months old, but a cheering link with home. By some mischance, like a sick joke, someone received an income-tax communication, which produced understandable rage from the recipient. Most letters brought comfort and encouragement, but some contained tragic family news of bombed homes and casualties or wives finding other loves. But there were some strange twists. One prisoner had news to say that his wife had left him and he was delighted, for he detested her. The news bucked him up considerably and contributed to his recovery. He organized a small 'party' later on to celebrate.

Allied aircraft flew over intermittently and in early March anti-aircraft gunfire could be heard down-river during a raid we presumed to be directed against the Tamarkan bridges. The raids were increasing noticeably and we drew encouragement from them and the consequent restiveness of the Japanese. In early June we learnt that there was to be a move of heavy sick to a new large hospital camp at Nakhon Pathom, 40 miles north of Bangkok. It was rumoured that conditions there would be an improvement on Chungkai. Men were allocated to appropriate groups and we collected our possessions and prepared to move. I retrieved my hidden drawings from the bamboo in the ground and stowed them in the false sections in my haversack together with my precious store of paints. I had been recording some surgical

cases for Weary and he hid a number of these in the false top to a
small table that he used at his bed space and which was to be taken
with him. To our great delight and relief, Weary was to move with
us and we looked forward to the change with renewed hope.

Hospital camp, Chungkai late 1943: Watercolour of a sunset showing
the lights from small cooking fires, situated at the ends of the huts.

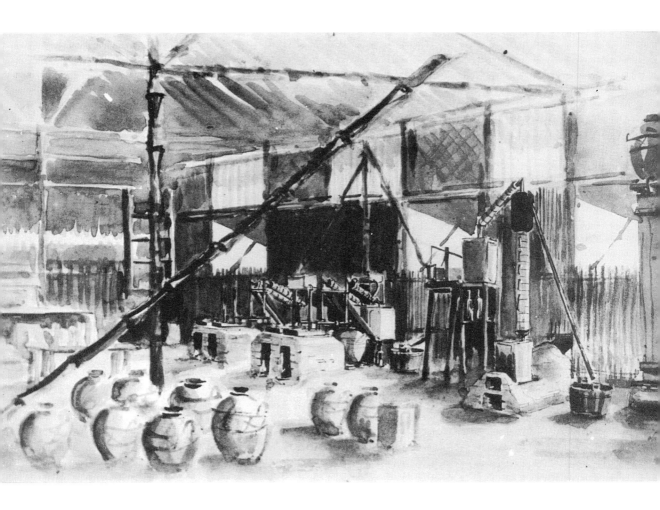

Nakhon Pathom Hospital camp, 1944 — 1945: Wash drawing
showing two stills made from old condensed milk tins, and a
fractionating column adjacent to the camp 'dispensary'. It was
here that a rice and yeast culture was formed in Thai jars and
then distilled in the two condensers to produce ninety per cent
alcohol used as the only cleaning agent available for surgical
purposes.

Nakhon Pathom Hospital Camp

IN MID-JUNE, 1944, we left Chungkai for Nakhon Pathom, packed into the all-too-familiar steel box-trucks, already at oven temperature. We rumbled southwards across the Mae Klong, eventually arriving at an immense railway marshalling yard at Non Pladuk, east of Ban Pong. Here we stopped the night. We were allowed out of the trucks and lay about at first on piles of sleepers talking and listening to the new sounds about us. It was a clear, starlit night and about eleven o'clock a reconnaissance plane circled the area accompanied by the wail of Japanese air-raid sirens. The marshalling yards were an obvious target and we were sitting in the middle of them.

During the night many of the sick were lifted back into the trucks, whilst others of us crawled underneath and lay on the earth and sleepers in the fresher air. The monsoon had already begun and we had no intention of being soaked yet again. I remember lying uncomfortably on the sleepers beside a young Suffolk farmer, Peter Clarke, talking about horses and veterinary practice, indulging in sentimental thoughts of the English countryside. Clarke had a nasty, sloughing tropical ulcer on his leg and was in great pain, but we both recalled those few strange hours with pleasure. Soon after dawn we were back in the trucks and moved off down to our next accommodation. The timing of our stop in the marshalling yards had been fortunate, for two days later a heavy raid occurred killing and injuring a great number of prisoners who were in a nearby working camp. During the raid a Japanese *socho*, at great personal risk, repeatedly entered burning huts to drag and carry out injured prisoners. It was yet another example of the strange contradictions in Japanese behaviour. Many severely injured were brought down to Nakhon Pathom soon after our arrival there.

The camp had been specially built to accommodate 10,000 heavy-sick men. The long huts were made of wood with attap roofing. There were trees within the vast compound – coconut palms, palmyra,

mango, pomelo and frangipani among others. Anti-malarial drains had been dug around each hut and the latrines had been provided with concrete pits so there was no fear of collapse during the monsoon rains.

From the encampment we could see the dome of an immense Buddhist *wat* or temple some 4 miles away, shaped like a giant handbell with its handle uppermost. The dome and spire were covered in orange and gilded tiles and long palm fronds had been slung across the dome in a half-hearted attempt at camouflage. This strange and wonderful *chedi* became a symbol of civilized existence for us and I longed to see it more closely.

Away from the Kwai Noi we missed the advantages the river offered: the chance to bathe after work, the ready source of water, its boats and people. I particularly missed the beauty of the jungle with its vast landscape of mountainous ridges covered in thick tropical rain forest, its gibbons, elephants, brilliant blue kingfishers and the acrobatics of the racket-tailed drongoes, and all the jungle sounds which had been such a continual source of interest and delight and helped to compensate for the appalling conditions in which we lived.

Nakhon Pathom had been established for some time and already contained sick from up-country camps. It had been under the command of a British senior officer and for far too long had needed radical improvement. With considerable difficulty and even opposition Weary once again had to undertake the Herculean task of making desperately needed organizational and practical improvements, and, with great determination, diplomacy and tireless energy, he succeeded. Our SMO was now Colonel Coates, an Australian neurosurgeon who had been a colleague of Weary in Melbourne. These two able men, together with surgeons such as Markowitz, Major Kranz and Major Hazeldon, made an imposing surgical team. On the medical side were Captain Vardy RAMC and Lieutenant-Colonel Larsen of the Dutch Medical Corps, both invaluable physicians experienced in tropical medicine. Some medical stores had been brought down from Chungkai, but

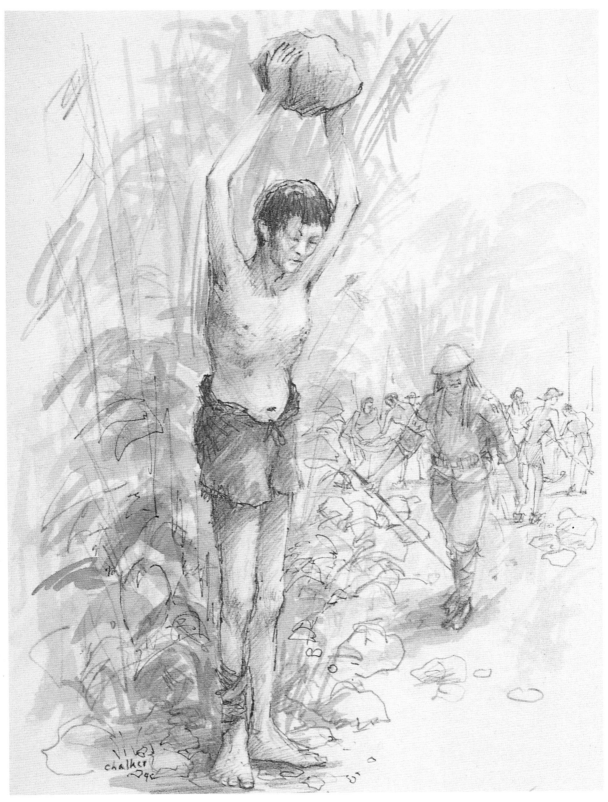

'Holding the stone': One of the all too frequent punishments meted out to prisoners during the 'Speedo' period 1942 – 1943 for not working hard enough on the railway trace.

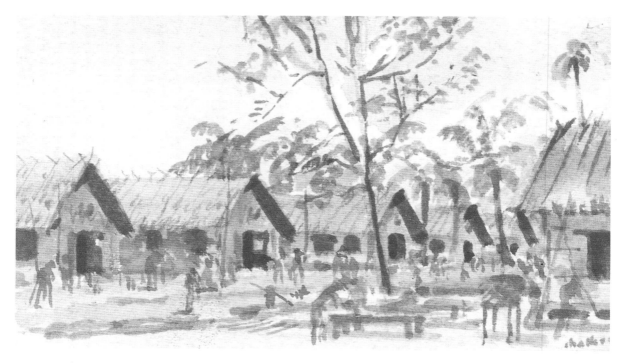

Nakorn Pathom Hospital Camp, 1945: Bed spaces were on wood and free from the miseries of sleeping on bamboo racks (original size 12cm x 4.5cm).

Vajirvudh College, Bangkok, 1945: After the Japanese surrender in August 1945 buildings in this area were used to house the Australian Medical HQ, where I worked with 'Weary' Dunlop. My living quarters were in a dormitory on the upper floor of a very beautiful Thai building with the traditional glazed and gilded tile roof and carved and gilded gable ends. 'Blue' Butterworth and I shared accomodation and we had real beds and pristine white mosquito nets!

supplies were still pitifully inadequate and there was an even greater need for improvisation than before.

Carpenters, metal-workers and artisans of all kinds under the direction of Majors Wearne and Woods began to produce a range of highly effective artefacts and equipment for hospital and general camp purposes. An ingenious quadruple needle for pinch-grafts was devised, together with a highly efficient rib-cutter and a spinal needle and syringe. A pedal-operated dentist's drill was adapted to power a small circular bone-saw, just over an inch in diameter, developed initially for use in a craniotomy for an American pilot with a brain tumour. Dental forceps had to be used as bone nibblers and old domestic knives were still being finely honed to take their place with the small selection of more normal surgical tools. As at Chungkai, stethoscope tubes provided rubber connections for various pieces of equipment. Cotton and silk replaced normal surgical catgut for surgical sutures. In addition, fine strips cut from the peritoneum of pig or buffalo, sterilised by boiling, soaked in a small quantity of precious ether and then finally in alcohol with a little iodine added, provided additional suture material.

As tropical ulcers granulated, pinch grafts were undertaken to close over the huge areas of raw, exposed tissue. Such procedures required stringent aseptic conditions and it is to the credit of those involved that so many were successful under such unhygienic camp conditions. It was here that Marko's life-saving method of direct blood transfusion came into full effect, using defibrinated blood, which, after being collected from the donor, was stirred continuously with a wooden whisk for five minutes after clotting commenced and then filtered through multiple layers of gauze before being administered to the patient. Thousands of successful transfusions were carried out in this way.

Another orthopaedic bed and an adjustable dentist's chair were constructed for use in Nakhon Pathom and the camp workshop teams continued to achieve the impossible. Artificial limbs of greater sophistication were constantly being produced, and many legless began to

get about without a stick or additional support and to enjoy each day a little more.

In a small extension of the camp dispensary Sergeant Chapman and a Dutch chemist developed a rice and yeast culture that they used to distil surgical alcohol. Pharmaceutical knowledge was used to extract flavouring additives from flowers and plants, as well as colour indicators for pH, to produce litmus paper and essential oils.

In Nakhon Pathom camp the Japanese insisted that all mobile patients and camp personnel participate in formal exercises in the camp assembly area. A Japanese soldier on a high bamboo platform conducted these sessions and the camp orchestra played Japanese children's tunes to accompany the exercises. Occasionally the orchestra jazzed up the music Glen Miller-style, much to our delight. The exercises were rhythmic, required thought and provided very enjoyable and necessary exercise without strain, and were far more beneficial in every way than the 'physical jerks' of British schools and army. It was in connection with the exercise of patients that I renewed contact with Skillikorn, the patient at Chungkai who had a mental breakdown and lived a Walter Mitty existence. With many others he had been moved down to Nakhon Pathom where a small 'secure' compound had been built within the camp. It consisted of a small hut, latrine, and an exercise area surrounded by a high fence of thick bamboos. As part of the physio-massage team, one of my duties was to visit this sad place and encourage the patients to undertake some sort of physical movement and to provide remedial treatment. Skillikorn was the only one in there who could display pleasure of any sort and each day he played a game of hide-and-seek with me in the latrine prior to doing the required exercise. The remaining patients were largely melan-cholics who sat hour after hour, silent and withdrawn, sometimes quietly weeping, frequently hanging rags or bits of old blanket over their heads like ancient crones. It was an unhappy place and I was grateful to Skillikorn for his sense of fun and the relief he brought, even inadvertantly, to those tragic figures.

Perhaps the most memorable and important parts of those devas-

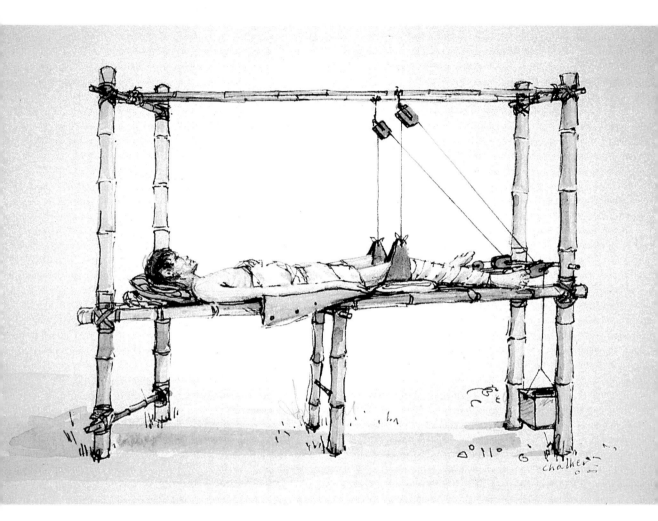

Orthopaedic bed, Nakhon Pathom Hospital camp 1944 — 1945: Bed made from bamboo lashed with rattan; ropes made from stolen hemp, blocks made in camp and weight tins filled with stones for traction. Five-inch nails punched through the tibia proved successful for traction.

tating years in Thailand were the extraordinary achievements which arose from the combination of great medical leadership, courage and devotion, combined with a vast range of determined, able and ingenious men of all ranks, and those with the courage to risk their lives outside the wire to barter or steal for desperately needed supplies. Together they produced a sort of corporate magic for survival over which the Japanese, despite their bestiality, had no control.

By July, 1944, Nakhon Pathom Hospital Camp contained more than 5,000 heavy sick men; during the following months the number increased to 8,000.

From the beginning of our stay in the camp aerial activity increased steadily and we could often hear bombers overhead and occasionally the distant fall of bombs. We assumed they were concentrating on the marshalling yards at Non Pladuk and the Tamarkan bridges. The air-raid sirens always upset the guards, who would start shouting and rushing about like disturbed hornets.

As all our camps remained without identification from the air we too were anxious at these times, remembering the casualties among prisoners in Burma and at Non Pladuk.

Frequently, for a few hours in the afternoons, the guards dressed themselves in thick papier-mâché armour, similar in design to their traditional fighting armour, topped with large fencing masks tied with tapes. With long mock rifles made of teak they engaged in vigorous bayonet practice, roaring hoarsely and jabbing as they rushed at each other, supervised by their *gunsos* or other senior officers. It was a disturbing and irritating racket for the sick patients within earshot and was probably a deliberate harassment.

Under the direction of the medical and surgical staff the physio-therapy unit grew considerably and was even more in demand, and with the help of the camp workshop ingenious and effective physio equipment began to emerge. A small area in one of the huts was now set aside for this in addition to work carried out in the wards.

As in Chungkai, the Japanese allowed a stage to be built on one side of the wide assembly ground. Though less picturesque in its

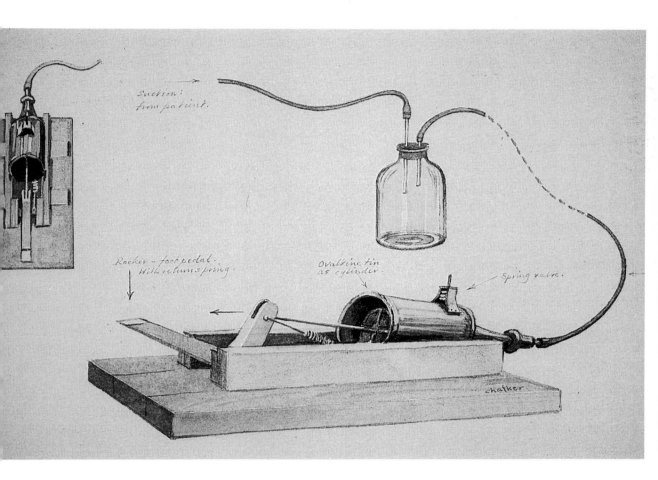

Surgical suction pump, Nakhon Pathom Hospital camp 1944 — 1945:
Made from an old Ovaltine tin scrounged from the Japanese
compound; wooden hide-covered plunger with spring valve;
attached to the drain bottle and to the operative area with rubber
from stethoscopes. Used right up to the release in August 1945.

setting than the stage in Chungkai, it was a more sophisticated structure built of bamboo and attap on a raised earth platform, with a shallow orchestra pit and equipped with dressing rooms, ample wings, and a drop-curtain of bamboo and 'flies' operated by ropes made of stolen hemp.

We were singularly fortunate in having some outstanding musicians, led once more by Captain Norman Smith, as well as a range of remarkable actors and producers. Outstanding amongst the latter was a Dutch humorist and political satirist, Wim Kan, a sort of Peter Sellers of Holland, and an internationally known actor and playright. He wrote five plays in Nakhon Pathom, all of which were produced first in Dutch and then in English. I had the privilege of acting in two of the Dutch productions and subsequently in the English versions. Another memorable actor and producer was Nigel Wright, an English geneticist from Malaya who had run a most successful theatre group in Kuala Lumpur. There was a great range of theatrical and musical talent to draw upon and productions were looked forward to with great enthusiasm. Burlesques, variety shows and plays were devised or written from memory, and once a cast had been agreed we wrote out our individual scripts on odd scraps of paper, sometimes sewing the sheets together to form a small book. Rehearsals were usually at night after work and there was no shortage of willing participants. At one time I remember rehearsing four shows concurrently. All scripts had to be submitted to the Japanese Commandant for approval and all shows would be produced or cancelled according to his whim and often without warning.

Costumes and props had to be made from any scraps of waste fabric or other items not needed by the medics: bamboo and copra matting, ends of rope and string, bits of mosquito netting, kapok from nearby trees, scraps of coloured paper or material, snake and animal skins, feathers and wood were all valuable. Needles were beaten out of small bits of soft metal such as brass from army equipment, and thread was pulled from rags. Professional tailors amongst us were a great help, but we were without an expert designer for women's clothes and had

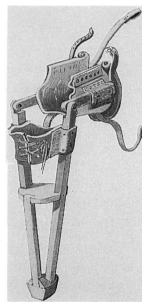
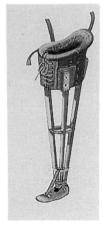
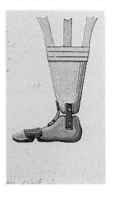

*Artificial limbs, Nakhon Pathom Hospital camp 1944 – 1945:*Types ranging from split bamboo to articulated prosthesis and apparatus for bilateral amputation patients. The buckets were made from old army packs stuffed at the upper ridge with kapok from nearby trees. Lacing and front panels were made from hides of animals killed in the camps for food.

to rely on our rather unreliable memory of female dress. One production of a Wodehouse play required the appearance of two women in their underwear and after an appeal to the camp as a whole two pairs of silk cami-knickers appeared. The owners saw to it that their trophies were returned and that their names were kept out of it! Kapok was used to stuff roughly made brassieres. Raw hemp stolen from the Japanese was teased out with bamboo combs, sewn onto skullcaps of mosquito netting and fashioned into wigs. These could be coloured with a mixture of soot, wood ash or ground-coloured clays mixed with tapioca 'goo' as an adhesive. Somehow we managed to cater for anything from straight plays to circuses, including animals and clowns. For a review written in Nakhon Pathom, a two-man elephant was formed of bamboo matting coloured with wood ash with remarkable success. It was hilarious when the rear legs collapsed during one matinée performance in a temperature of over 100°F. Matinée performances in the tropical heat could turn into farces as make-up and moustaches ran, but the shows were of remarkable standard and helped to maintain some sense of normality and relief from the surrounding misery.

Colouring for make-up and costumes came from various finely ground clays that had been excavated from rainwater storage ponds dug in the camp. Terracotta, grey, bright-yellow and near-black clays were dried, powdered and finely ground. To this we added any animal grease available, or boiled tapioca root, producing an adhesive which would stick to cloth, bamboo matting and mosquito netting. Soot and burnt cork, the old standbys, were both part of the make-up box, together with chalk and any red mercurochrome we were allowed by the medics. An excellent dark-brown stain could be made by boiling bits of bark from mango and other trees.

While our prison existence was remarkable for its many outstanding examples of unfailing courage and dedicated concern for others, we were nevertheless a cross-section of ordinary humans with the usual range of failings and foibles. Some behaviour was by no means free

Wim Kan, Nakhon Pathom Hospital camp, early 1945: Sketch portait
of the Dutch actor and playright.

of self-interest and in a few cases this led to deliberate and detestable acts which should not be hidden.

Some of us will never forget the occasion when a high-ranking British medical officer, unbeknown to his colleagues, put a sick man on an up-country party for railway work out of jealousy for his outstanding capabilities as an actor and producer in the camp theatre. The officer concerned fancied himself as a playwright and his action against this gentle, erudite English scientist was incomprehensible. The action was discovered by a medical orderly who knew that the victim was a friend of mine and I reported it in turn to our senior Australian doctors who were distressed and angered and at once took the name off the work-party list. The man concerned was older than many of us and was a sick patient awaiting the removal of a growth on his back; to have sent him up-country would have almost certainly resulted in his death. As it was, having reported the matter I was sent for by the officer concerned whose irrational ravings only too clearly confirmed his guilt. After telling him that I thought his action was tantamount to murder he placed me on a charge for insulting a senior officer. My reply was that I would ask for a court-martial in the event of our surviving the camps and that I would consider it a duty to ensure that his despicable action was officially investigated. His threat of a charge against me was never mentioned again and it was interesting to observe that this man was one of the first to be given a civil award in the post-war handouts for senior officers. For what, we wondered?

In an up-country camp, in an incident which a number of us remember with anger, it was discovered that two British officers, one a regular, had been selling bottles of quinine tablets to outside contacts for their own personal gain, whilst men in the same camp were dying of cerebral malaria and blackwater fever for lack of it. As far as I can remember the matter was quickly hushed up and those concerned removed from the camp before they could be lynched.

Late one morning in mid-December, 1944, a large number of heavy aircraft flew in successive waves overhead. They bombed a target some

distance from us and we listened with pleasure. In all the raids by Allied aircraft we saw no evidence of Japanese aerial opposition and hoped that the tide had turned against them in the Pacific.

We wondered at the same time what might happen to us in the event of a successful push by the Allies, and with our long experience of Japanese behaviour felt that anything unpleasant was possible. We began to suspect that the Japanese were not having things all their own way, as sick men coming down from up-country brought reports of the railway being heavily bombed and of continuous damage to the track and rolling stock restricting rail traffic to Burma.

Yet for us the daily routine continued without change. We had enough food and water to exist on and lived a day-to-day existence with as much fun as we could put into it. We were dependent upon each other and drew great strength from our giants such as Weary and Marko. More sick men died or recovered, parties were assembled for up-country repairs and maintenance to the railway and groups of prisoners were ruthlessly sieved out by the Japanese for transfer to Japan. Daily, the 'Last Post' was played, and the cemetery increased inexorably. One day near the cemetery a Korean guard gave me a sick smile – or a smirk, I couldn't tell which – as he pointed to the growing forest of pathetic crosses and said, 'All men long-yasumi-ca?'. A very long rest indeed.

As elsewhere, the Japanese and Korean guards ranged from the sadistic to the reasonable, and there was also the occasional benign simpleton. One of these, an ugly Korean, 'Watchee-Watchee' by nickname, became our ally by his own stupidity. His absorbing interest was to buy watches from prisoners to sell for a vast profit outside the camp. He used to stride through the huts gesturing and grimacing, all the time saying 'Watchee-Watchee'. We kidded him that we still had some contraband and whenever he heard that a search was to be sprung he would ride like a demon on his bicycle through the huts shouting 'Searcho-searcho' in order to preserve his potential market. The possession of watches or jewellery was strictly forbidden by the Japanese and such things were confiscated if found during a search,

this sometimes accompanied by punishment. The exception was for medics, who were allowed to keep a watch by permission of the Commandant.

Another tiny Korean guard used to come into our hut to visit a violinist from the camp orchestra. He used to sit cross-legged on this man's bed-space for an hour at a time humming Korean and Japanese tunes for the violinist to play back for him. He always brought a small gift of food for his 'music-man' and thanked him graciously after each session. This unusually gentle guard professed to be a good Buddhist and was never personally involved in any ill-treatment of prisoners. We enjoyed his coming and his quiet music.

Our third and last Christmas as prisoners, at Nakhon Pathom Hospital Camp, was eagerly anticipated and well planned. As before there were carols on Christmas Eve and services for those who wished to attend on Christmas morning, some taken in the wards for immobilized patients.

The cooks produced memorable meals: a breakfast of rice 'porridge' and an egg; a lunch of meat and extras followed by real tea and Christmas (rice) 'cake', and a crowning evening dinner of distinguishable meat in our mess tins.

Nigel Wright and I paid a visit to our friends in the dispensary in the morning to greet Geoff Wiseman and his partner, Sergeant G. W. Chapman, and we were given a tiny tot of camp produce, flavoured with lemon grass, that had a kick like a mule. A close friend and fellow artist, Rob Brazil, had joined me in making Christmas cards with the help of my paints and we had a great deal of topical amusement with them at each other's expense. After lunch a 'race meeting' was held, a sort of Grand National complete with a water-jump. Weary Dunlop and other medics provided remarkably energetic mounts straddled with a variety of light 'jockeys', and all had an hilarious afternoon. The camp orchestra provided music throughout the day with a concert at night, and the theatre company put on an evening performance. It was the most enjoyable camp Christmas we had known.

We saw the New Year in with more music, singing and as much

celebration as our meagre circumstances would allow, and once more a year began with renewed hopes. In mid-January all non-medical officers, patients or otherwise, were moved out of Nakhon Pathom to other camps, presumably to avoid any organized resistance by prisoners if any such opportunity occurred. With fewer sick pouring into our camp and with working parties still being sent back up-country and to Japan the camp population was reduced to about 5,000.

Late in May there was a rumour that the war in Europe was over and the following day our small Korean guard came in and made two significant comments, 'Germany finiss-ca' and 'Soon all solja finiss-ca'. We hoped that this meant that the Japanese war might end soon and not that all prisoner 'soljas' were to be 'finiss-ca'. The outside grapevine soon confirmed that the European conflict was at an end and we were immensely cheered by this news. At least those at home might be safe at last.

In June the pattern of Japanese behaviour changed and it was obvious that something was disturbing them. It seemed, via the grapevine, that the Americans were getting the upper hand in the Pacific and we hoped that things were going well in Burma. Bombing of the railway continued and we knew that the bridges over the Mae Klong at Tamarkan had been badly damaged and it seemed true that Allied bombers were having little opposition in southern Thailand. One night, as we watched the high black specks of Allied aircraft flying south on a raid, two of the planes switched their port and starboard lights on and off quickly, which raised a cheer from us below, much to the anger of the guards.

Our camp perimeter consisted of a wide, deep trench beyond which rose a huge bund nearly 15 feet high, patrolled day and night by armed sentries. Disturbingly, machine-gun posts were now being set into all corners of the bund commanding the trench, which could obviously be used as a mass grave. A rumour had already been circulating that all prisoners of war were to be eliminated in the event of an Allied landing on the Malay Peninsula or in Thailand. There was evidently more truth than rumour in this, and after our release we learnt that

there had been an order from the Imperial Japanese Army that under such circumstances all prisoners of war were to be shot. Weary knew of this and had already organized a secret defence group of the more active prisoners as well as a plan of attack against our guards and the machine-gun posts if extermination of prisoners was attempted. As if to confirm this disturbing possibility our musical Korean guard came in one afternoon at the beginning of August and indicated to two of us quietly and sorrowfully that 'all soljas' were going to be 'finiss-ca', and 'soon'. This was supported by 'American, Engliss solja, boom-boom' and other indications of imminent attacks to be expected not so far away. He repeated his apologetic 'No-good-ta-nas', shaking his head, and we got out of him some indication of just when this catastrophe might be happening to us. Indicating 'days' with his fingers, it seemed that he had learnt that we might have until 21 August. He obviously hated the whole wretched business and, like us, just wanted to go home, but we took his formidable forecast as a mere possibility and went about our business with our mouths shut.

The Koreans were generally less offensive to us at this time and it seemed that their attitude both to the war and to their Japanese masters might already be changing.

Tension was building up and even 'Watchee-Watchee' stopped his bicycle rounds. Something was up, and continuing to live on optimism as we had done for three and a half years, we hoped that somehow, someone would make our war end. Then, on 14 and 15 August, there was a stir among our own senior medical officers as well as the guards. In the early evening of 16 August, Weary, Coates and other senior officers returned from a summons to the Japanese Commandant and assembled us all in the area by the camp theatre. Colonel Coates then announced that the Japanese had capitulated and that we were prisoners no longer. There were cheers, tears of relief and intense delight. Within a few minutes a Union Jack, an American flag and a Dutch flag appeared from hiding and were floating high on bamboo poles. We walked about the camp, somewhat dazed, as free men.

The following day we learnt that two immense bombs had been

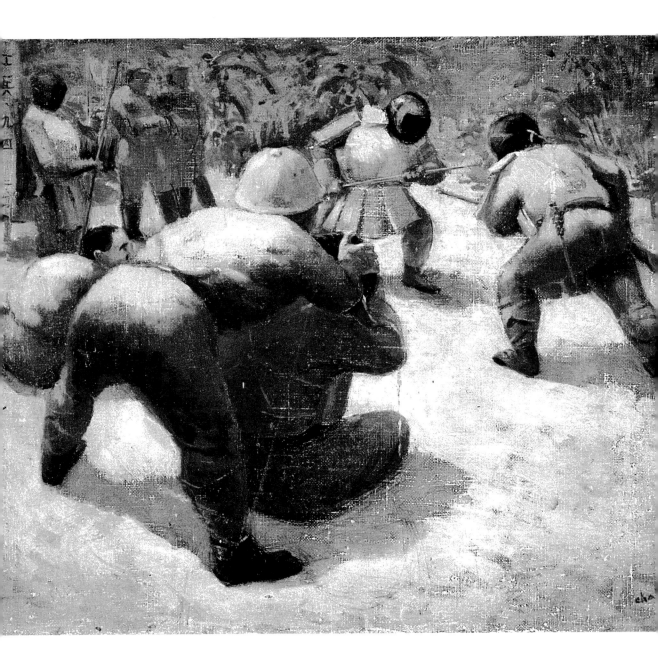

Bayonet practice, Nakhon Pathom Hospital camp, 1945: Japanese and
Korean guards polishing up on their skills.

dropped on Japan, but there were no details. We understood that this was what had ended the war and saved so many thousands of lives. Some it couldn't help, however, and sadly we continued to carry emaciated remains to the cemetery, the bugle continued to play the 'Last Post' and those sad little bamboo crosses still had to be made. But at least help was at hand for the very desperately ill and we were still alive.

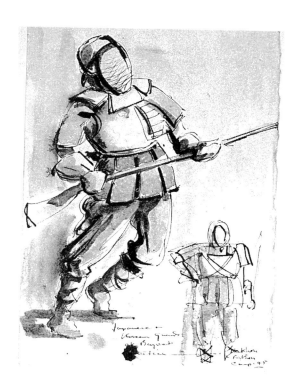

LIMBO

THE SITUATION WE now found ourselves in was indeed strange. The Japanese were still armed and continued to guard us for the next two weeks – for our own safety, it was said – although ostensibly we were under the direct command of our own senior officers. There were no Allied troops in Thailand other than a handful of courageous American and British commandos who had been hiding with Chinese and Thai guerrillas in the jungle. With large concentrations of frustrated and fully armed Japanese fighting troops spread all over Thailand, the circumstances were tense and delicate.

For the time being we were confined to the camp while our senior officers went down to Bangkok to contact appropriate organizations for urgent medical help and food supplies. Work in the camp continued as before and preparation had to be made for the movement of the most desperately sick. Within a few days the first few Dakotas arrived, bringing supplies of drugs, clothes, blankets and mosquito nets. These heaven-sent planes came in at 100 feet, dropping huge bales along the central track in the camp and the crews waved to us as they flew over. This was the first direct contact with our own people from outside that we had had for nearly four years and it was profoundly emotional. We had an immediate issue of new khaki drill clothes, but after years of making do and cherishing our personal rags and homemade clothing the new issues seemed uncomfortable and strange. I found it difficult to bring myself to dispose of my old rags and especially the lice-ridden remains of my old woollen jersey that had been a friend for so long.

A few days after the Japanese surrender a jeep was driven into the camp, the first we had ever seen. It contained men from the commando group, who gave us the first news of the German atrocities in Europe: of Auschwitz, Belsen, Buchenwald, Treblinka and elsewhere. Many of us were stunned that western Europeans so close to us could be responsible for organized genocide. It has left an indelible mark.

After two weeks some of us were officially allowed outside the

camp. I walked out one morning with an Australian friend, Wally Kirley, without having to bow to the guards, without being screamed at, without *kioyski* and standing to attention, without the hitting, the searches, and the unfailing need for watchfulness and constant vigilance. But the feeling was still there and we progressed with care and the keen instincts of hunted animals. We walked barefoot into small kampongs and eventually into the outskirts of Nakhon Pathom town, where we came upon a small kindergarten full of Thai children and were immediately surrounded by lovely little creatures who danced round and round us laughing at the size of our European noses. This was an enchanting introduction to freedom and an unforgettably tender moment. From there we went to the great Pra Pathom Chedi, the Buddhist temple we had watched from our camp for so long. Thais were making offerings of lotus blossoms to Buddha and with great kindness offered us food and flowers from the stalls outside the *chedi* perimeter. The beauty, sounds and smells of that lovely place and its gentle people that day are always with me.

In the camp our food had improved vastly, but we continued with our rice-based diet and with great care, for our shrunken stomachs had to be nursed back slowly to any more substantial foods. We were by no means free of tropical disease and malarial rigors, and continued attacks of dysentery were still very much a part of our daily pattern. At the end of three weeks the guards were withdrawn from the camp. Some of the most sadistic had long ago deserted, fearing reprisals, but one morning we noticed our musical Korean guard sitting on his army pack near the guardhouse and we went over and talked to him. It appeared that the Koreans had been summarily discharged by the Japanese and had been left to make their own way home. His was in Korea, and he was uncertain as to how to begin his return. This callous attitude on the part of the Japanese towards their own troops was a further surprise and we were sorry for this strange, sad little man. We gave him some money and a few cigarettes and wished him well. He was almost tearfully grateful. At least *we* could look forward to a passage home.

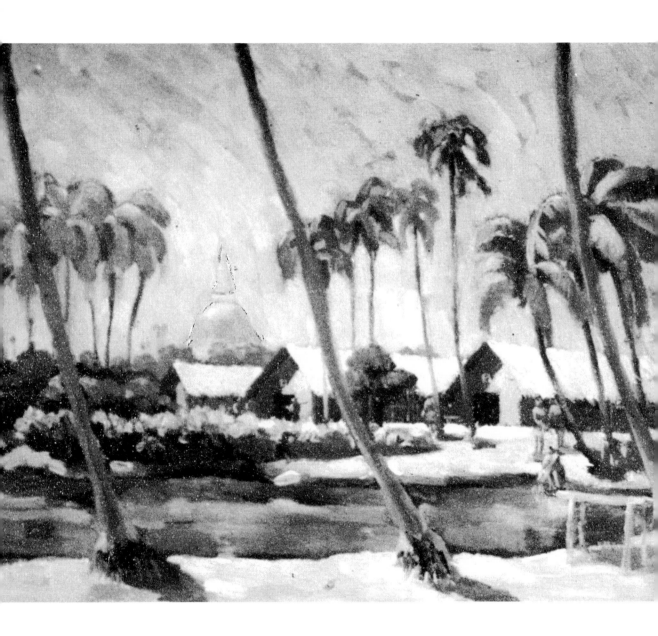

Nakhon Pathom Hospital camp, 1945: Looking across the camp towards the great Thai Chedi, Buddhist temple, situated in Nakhon Pathom town.

It was about this time, in early September, that Lady Louis Mount-batten arrived in Thailand to visit a number of prison camps. We will always remember her initiative, concern and kindness in making a trek to the camps when the situation in Thailand was still dangerous, and for playing a large part in accelerating the airlift and movement of the most desperately ill from Nakhon Pathom.

At this time also, Weary Dunlop left Nakhon Pathom to go down to Bangkok to set up an Australian HQ. Within a day or two I received a message from him asking me to join him and assist in completing official war records. This was an immense privilege, and I packed my few possessions and the drawings and paintings now out of hiding, and prepared to depart. Heavy sick were being moved out and I said goodbye to friends and patients I had worked with and had a last walk round the place that had been my home for almost a year. It was with mixed feelings that I saw the last of the camp from the back of the truck taking us away from that prison existence; from the compan-ionship, the friendships, the battles to survive, the rows of pathetic sick hanging onto life by a hair's breadth, the ingenuity and corporate efforts to overcome almost impossible difficulties, the fun and the laughter, the fascination of the jungle, and all the thousands we had to leave behind.

It was an emotional tug of war that still remains, and like so many of us who were there and survived I would not have missed it.

Of the 60,000 British, Australian and Dutch prisoners of war sent to work on the railway, nearly 20,000 died there. The remainder – the maimed, the wrecked and the relatively fit – survived by a last-minute quirk of fate to return home. Many POWs were drowned in the China Sea on their way to Japan and hundreds more lost their lives in the Japanese labour camps. Of the 200,000 Chinese, Malays, Tamils, Thais and Burmese who were forced to work for the Japanese on the railway project, almost all perished. The exact numbers will never be known, nor will the toll of civilians during the Japanese occupation.

Had it not been for the atomic bomb, Hiroshima and Nagasaki,

and had it been necessary for the Allies to invade Japan, Thailand and the Malay Peninsula, another million or more Allied troops at least would have been lost, as well as untold numbers of innocent civilians. The 40,000 survivors from the railway project and the 70,000 prisoners in Singapore and elsewhere would also surely have been exterminated. Many of us who survived, by a matter of days, remember with deep gratitude the fact that the Americans achieved the atomic bomb before the Germans and Japanese. It had been a close race. We also remember with gratitude the price America paid to achieve victory in the Pacific, her vital contribution to the war in Europe, and her life-saving supplies of food and war materials to England, without which we should surely have been overrun. At least some of us who survived will remember our debt to them, and to the Australians, New Zealanders, Indians and Africans who sacrificed so much on our behalf.

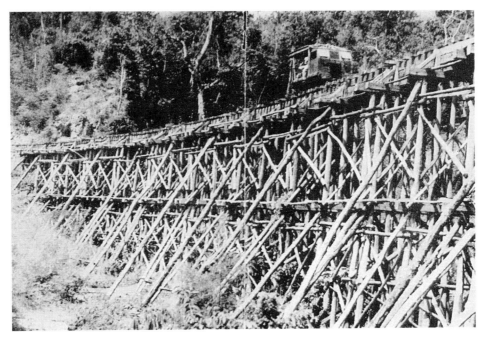

Hintock: The Pack of Cards Bridge built by Australians from nearby teak and kapok trees.

Bridge over the Mae Klong: Southern end of the Thai — Burma railway, looking north towards the mountainous area in the distance. Spans were destroyed on two separate occasions during bombing raids in February and June 1945. Repairs were carried out by POWs.

BANGKOK, RANGOON AND HOME

I ARRIVED LATER that day at the Australian medical headquarters, established in the buildings of the Vajirvudh College (the Eton of Bangkok), which was set in beautiful grounds full of flowering trees and shrubs and with a small lake. Here I reported to Weary and found my quarters. To my delight 'Bluey' Butterworth, Weary's renowned batman and bodyguard, was here and we settled down to enjoy every minute of our release as well as the work we were there to do.

The situation in Bangkok was particularly strange. The Japanese remained fully armed and their officers continued to drive about in the best cars wearing their automatics and Samurai swords. The city was alive with fighting troops who were for the time being free to move as they wished. At the same time Japanese and Korean war criminals of all ranks were being ferreted out and carted off by the lorry-load for interrogation. It seemed as unreal as Alice's experiences in Wonderland.

We had been warned by the commandos and paratroopers that the situation was extremely delicate and that there must be no frictional activities of any sort which could trigger a small war. To complicate this very odd situation even further, old scores which had their origins during the occupation were being paid off between the Chinese and Thais. The Thais had had little option other than to accept the Japanese invasion, but the Chinese, who formed almost half of the population of Thailand, were determined to resist the invaders in every way, passively or otherwise. They had suffered badly during the occupation and were mindful of the massacres of their own people in China during the Sino–Japanese war. Inevitably complex problems arose between the Chinese and Thais, especially where there had been collaboration between Thais and Japanese, in some cases involving Thai informants.

In consequence, small internecine battles were breaking out from time to time between the two factions, sometimes between civilians

and Thai police and involving gun battles in the streets. I was caught up in a few of these: the most amusing incident happened when I was in a Chinese eating-house and bullets flew in just above our heads, splintering huge mirrors and showering us with glass. It was like a Wild West film sequence, and afterwards we swept up the glass and continued with the meal. It all seemed part of the daily routine and there was much laughter. A paratrooper whose bed was next to mine in the HQ pressed one of his spare Sten guns on me, together with an ample supply of magazines. This I carried at all times while travelling about in Bangkok, once or twice having to use it in retaliation to odd sniping bouts in the town.

The work with Weary was a delight and I had the chance to see a great deal of the old Bangkok and its lovely architecture: an Aladdin's Cave where everything seemed possible. To enhance this magical existence I was invited to stay with the family of a German professor, a brilliant eye specialist who had held the Chair of Medicine at Berlin University as well as being a surgeon of considerable standing. A Jew, he had been hounded by the Nazis and the Gestapo and had managed to escape with his family to Abyssinia; after a few years they had settled in Bangkok. His wife was an Aryan, an anti-Nazi journalist and a concert pianist whose Prussian husband had been murdered by the Nazis, and they had two children, a boy and a girl. The son, Peter, was a natural linguist and was being used at Weary's HQ as an interpreter: he spoke immaculate English, French and German, Thai, Cantonese, Mandarin and Abyssinian. He was 19 and intended to read mathematics at university, a subject he found extremely difficult. I met Peter at the HQ. He became interested in my war drawings and invited me to meet his stepfather to show him the medical records in particular. This took place one evening at their lovely house in the centre of Bangkok and after a sensational Thai meal we sat with his rather stunning 18-year-old sister and the professor whilst his mother played Mozart, Liszt and other music to us on her Bechstein grand. This coming so soon after the squalor of the prison camps it was hard to keep tears back.

Further kindness followed when the professor invited me to stay with the family while working in Bangkok. Weary generously gave his permission and for the remainder of my time in Bangkok I lived with the Jacobsohns and through them saw a great deal of the city and its people. I was taken to a range of exotic functions where, among great Thai elegance and beauty, I felt like a dusty jackaroo from the outback. I met Chinese and Thai merchants and a range of profoundly interesting people. We travelled in long-boats through miles of *klongs*, explored temples, sat and feasted with traders in their canoes and revelled in the magic that only the Far East can provide. I had the chance to see a good deal of the professor at work in his operating theatre and made a few surgical drawings for him. My days between the work for Weary and my time with the Jacobsohns were packed with delight.

Such lotus-eating had to come to an end, with records complete as far as we could take them in the time, Weary had to return at last to Australia. It was now late in the year and I had hoped to return via Australia with him as there was still much to do. The stranglehold of the British army was still there, however, and my happy attachment to the Australians was accordingly severed. I said my goodbyes to Weary and Bluey: we had been through so much together and like many others I owed my survival to Weary. There were more sad partings to be made with Professor Jacobsohn and his warm family, and all this was not an easy business.

It rained the day I left Bangkok and we splashed our way to Dom Muang airstrip in one of the commando jeeps to catch a service Dakota leaving for Rangoon. It was still an adventure, but I felt the loss of my close friends and companions and it was a gloomy flight northwards sitting on the floor of the transport plane, bumping our way in a storm high above the mountains where we had spent those strange years. In Rangoon I shared a comfortable ridge tent with a most entertaining Scottish REME sergeant-major from an Indian unit which had been all through the Burma campaign. For the three weeks we were there awaiting a ship to the UK, I had a hilarious time. He

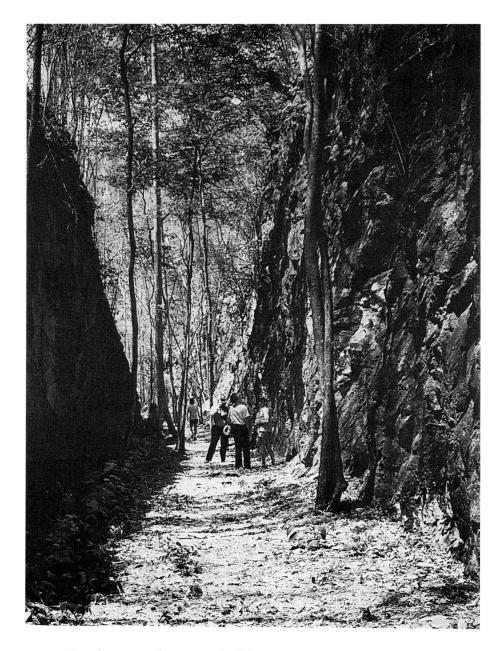

Hintock cutting today: Typical of those appalling cuttings that had to be made for the railways in Thailand and Burma.

seemed to possess a jeep of his own and each day we drove up the Prome Road about 50 miles to his old unit where there were some lakes and where, with the aid of a collapsible landing craft and an immense American outboard motor, we spent hours surfboarding in the sun. Our evenings were spent with Indian Army friends and we lived on superb Indian food.

Our weeks here went all too quickly and ended with a memorable *ramsammi* given by the Indian troops for their sergeant-major, to whom they were obviously very attached. I was privileged to be with him for this and we ended up singing our way back down the Prome Road (still full of shell-holes) at three in the morning in the jeep, both very much the worse for wear and still sporting round our necks the heaped leis that the Indians had showered upon us at the ceremony. The following day we were squeezed into an already overcrowded ship en route for England. For some incomprehensible reason the RAF Commandant demanded that all ex-prisoners do some sort of guard duty, despite that fact that the ship was packed with about 6,000 fit troops (not ex-POWs). The few of us who were POWs were mostly still unwell and could not take the ship's food. Within a few days, most of the POWs had to be taken into the hospital bay and remained there for the journey home. I slept on deck for the whole journey until we reached the Bay of Biscay when it became too cold and wet, for the conditions below were appalling and more foul, it seemed, than our old bamboo huts. It was winter and our journey up the west coast of England to Liverpool was made in thick fog and driving rain and we sheltered anywhere we could other than down below for those last two days.

On the quayside a formal greeting was read out to us by two pantomime generals. One was extremely tall and thin and the other very fat and stunted. Each wore a greatcoat reaching almost to the ground, reminiscent of Georg Grosz's satirical drawings of pompous German officers in the First World War. It was difficult not to laugh out loud and their bored voices reflected their lack of interest. From here we were taken to a transit camp where we were greeted by those

wonderful ladies of the Women's Voluntary Service and the Salvation Army, who treated us to a delightful meal, sewed medal ribbons onto our tunics and attended to our needs with all the kindness that they had so consistently given throughout their long war. We were grateful and will always remember the warm reception they gave us.

We slept fitfully that night in a freezing Nissen hut, its concrete floor running with water, and were woken early to receive a hot breakfast. Afterwards we were taken by lorry to Liverpool station. It was now well over four years since I had arrived here for embarkation and I felt excited, nervous and strangely alien at my impending reunions. After telephoning my wife and my people to let them know my probable time of arrival in London I sat shivering in my ill-fitting, new army greatcoat and my old battered bush hat, awaiting a train for the last lap home.

INDEX